OWLS

OWLS
THE SILENT FLIERS

R.D. LAWRENCE

FIREFLY BOOKS

A FIREFLY BOOK

Cataloguing in Publication Data

Lawrence, R. D. (Ronald Douglas), 1921–
 Owls : the silent fliers

ISBN 1-55209-146-5

1. Owls. I. Title.

QL696.S8L39 1997 598.9'7
C97.930350-8

Firefly Books (U.S.) Inc.
P.O. Box 1338, Ellicot Station
Buffalo, New York 14205

Design: Leah Gryfe
Electronic formatting: Frank Zsigo

Printed and bound in Canada

97 98 99 00 6 5 4 3 2 1

CONTENTS

FOREWORD

Round about the caldron go;
In the poisoned entrails throw

. . .

Fillet of a fenny snake
In the caldron boil and bake;
Eye of newt and toe of frog,
Wool of bat and tongue of dog,
Adder's fork and blind-worm's sting,
*Lizard's leg and **howlet's** wing,*

. . .

Macbeth, Act IV, Scene I.

The above lines serve to remind that owls ("howlets") have long been persecuted, since even before the time of the early Greeks—some three thousand years ago—onward through the Roman era, during the Middle Ages and to the present day, when numbers of individuals continue to believe that owls are harmful to the environment because they prey on species that are held to be "desirable" wildlife.

Apart from those of such persuasions, there remains in North America, as well as in the Old World, a relatively large number of humans who continue to believe that owls are the harbingers of death, and some who perpetuate the belief of the Romans, that owls should be killed and burned. Then, too, the Chinese at one time believed that owls were associated with the god of thunder and lightning, and the effigies of owls were frequently placed on rooftops to protect homes from fire. In fact, it is interesting to note that the early folklore of owls in China was very similar to that of various regions in Europe. In Sicily, for example, it was generally

believed that the horned owl always began hooting around the home of an ailing person and kept calling for three days thereafter. The Ainu of Japan carved owls and placed them on various parts of their houses in the hope that the birds, thought to bring pestilence and famine, would stay away from the home.

Today, in parts of Germany, Hungary, Austria and the Czech Republic, owls continue to be thought of by some people as the harbingers of death, while throughout Eurasia owls are also believed to be familiars of witches. During the early Christian era, the church saw owls as the evil companions of Satan, demonic distributors of sin. In the view of many early priests and some influential lay Christians, these birds represented the Jews who had spurned Christ. In fact, the owl, because it is associated with darkness, was a perfect target for those who believed in its evil character and disposition.

Because of its basis in ignorance, there may be some excuse for the attitude of the early Christians, but there is no excuse whatsoever for those who today shoot owls for sport at every opportunity. Nor is there any excuse for others who kill owls—as well as hawks and eagles—by using leg-hold traps, vicious instruments that are set atop poles and baited, when owls are the target, with live mice, which are tied just below a trap. Attracted by the struggling rodent, an owl will land on top of the pole and will set off the gin. The trap's jaws break the bird's legs and hold it prisoner until it is released and killed the next morning. Additionally, owls are unable to escape the viciousness of those who, on finding a nest, smash the eggs, or, if the owlets have hatched, kill the young.

On the positive side, however, many people today—almost certainly the majority—are attracted to owls, and especially enjoy hearing their calls between evening and dawn.

It is now impossible to determine exactly when humans first became interested in owls, but from ancient writings we know that the

Greeks had already developed a close relationship with these birds early in their history, especially with the small brown owl, *Athene noctua*, which they believed to be a close companion of Pallas Athena, the putative goddess of wisdom, fertility, the arts and warfare. Athena invariably traveled with an owl on her shoulder, although it is not known whether it was always the same owl or if others of the species took turns riding with the goddess. Greek writings also record that Pallas Athena could transform herself into an owl, in the guise of which she was said to travel periodically throughout her realm in order to watch over her subjects and to listen to their concerns.

The following story may be apocryphal, but ancient writings record that in 490 B.C., after King Darius I of Persia landed with thirty thousand troops on the Plain of Marathon intent on taking Athens, the ten thousand Greek defenders soon became hard pressed and were actually in danger of losing the battle when a little owl, *Athene noctua*, flew over the Greek soldiers and landed on the shoulder of General Miltiades. The Greeks, it is said, believing that their goddess had come to their assistance, rallied, and eventually routed the Persian invaders.

The legend probably gave rise to the widespread belief that *Athene noctua* was highly intelligent and was, indeed, the goddess's alter ego. Such a belief, coupled with the complete defeat of the Persians, endeared the little owls to the citizens of Athens. Apart from encouraging the birds to breed in the Parthenon, wealthy Athenians carried them about on their shoulders and in cages, and encouraged the birds to nest in their gardens and in other locations of the Acropolis, the elevated, flat area upon which the city was built. The followers of Athena believed that *Athene noctua* and, indeed, all other owls were gifted with a high level of human intelligence; but, although the Greeks were convinced that the birds understood human speech and therefore could converse with them if they so wished, the owls stubbornly refused to answer questions.

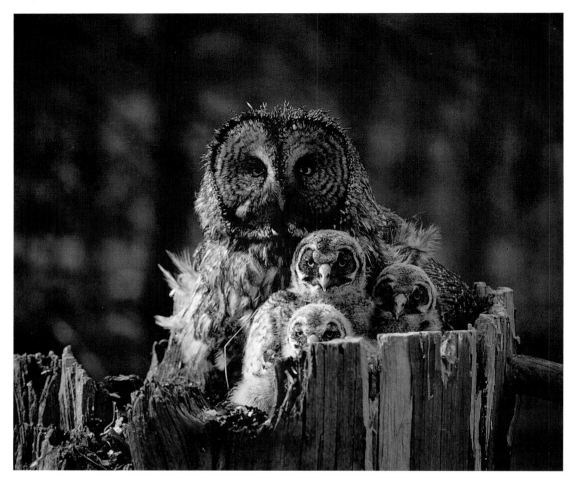

Great gray owls often raise their young in the abandoned nests of crows or hawks.

Despite the affection in which the owl was held by the residents of the Greek capital, numbers of northern Greeks feared and hated not only Athene, but *all* owls, believing them to be the harbingers of death and considering them to be stupid. These beliefs were undoubtedly passed on to the Romans and continue to exist in the more northerly villages of Greece as well as in similar regions in the Balkan states and in other parts of Europe.

Owl legends continued to develop over the millennia, including one which has it that during the twelfth century the warrior-chief Genghis Khan and his troops took to decorating themselves with owl feathers after an owl supposedly showed the Mongol chief a pathway that allowed him and his men to avoid a confrontation with

an overwhelming enemy force. Needless to say, many owls were thereafter killed for their feathers!

Similar legends abound up to the present day, one of which claims that the feathers, eyes and other body parts of owls are able to ward off evil and are also able to cure a number of diseases. Such beliefs, held in many parts of the world, have led, and continue to lead, to the death of owls. Indeed, because the eyes of owls are believed to hold magical properties that can cure many diseases when dried and ground into powder, there exists today a brisk and lucrative market for them in parts of Europe and in Asia. This trade should have been outlawed in North America and elsewhere, but it continues unabated because almost no owl species is considered to be endangered.

The price for owl eyes depends on their size. The dried eyes of snowy, great gray, great horned and barred owls command the best prices. In North America, depending on species, size and condition, prices range from $100 to $200 for both eyes, and from $50 to $100 for one eye. For sales in Asia, a North American or European dealer is likely to receive $1000 or more per dried eye. In addition, feathers and beaks are supposed to ward off evil, and clawed feet are sold as curios. All such parts fetch for a dealer a variety of prices, depending upon the country in which they are sold.

Nevertheless, regardless of the fear and hatred in which owls are held by the foolish, and despite the supposed magical properties ascribed to their parts by the superstitious, the great majority of people continue to be fascinated by owls.

There can be no doubt that owls are intelligent and are "well tutored" by Nature in the art of survival within their wild environment, but they cannot, of course, recognize the majority of the dangers posed by humans. In fact, owls are perhaps too confident, often allowing total strangers to approach within a few feet of their roosts. And it is

a fact that once owls have put their trust in a person, they actually seem to enjoy human company, as appears to have occurred in China in 1992. According to a Reuters report from Beijing in June 1995, an owl in the province of Jiangxi became attracted by color television programs that it first saw through the open window of farmer Zhang Liuyou's home. The Reuters report, picked up from the *China Daily*, noted that the owl actually flew into the farmer's room, but later found a perch outside the house from which it could watch the television and where, according to the Chinese newspaper, it continued to watch Zhang's programs every night! Unfortunately, neither the *China Daily* nor Reuters identified the owl's species.

Much earlier, during the mid-nineteenth century, an English ornithologist, G. B. Meyers, noted that a barn owl in the county of Kent became so tame that it would enter a cottage through "door or window" almost as soon as the family sat down for their evening meal, settling itself on the back of a chair or at times actually hopping on to the table. The family, reported Meyers, had earlier been in the habit of putting food outside for the owl, but after the bird entered the home for the first time, they continued to feed it in their dining room. Meyers, however, did not report on the kind of food that was given to the owl.

Some years ago, as I was returning home at night through our forest, I was considerably startled when a saw-whet owl elected to land on my left shoulder. The bird found me in the dark as I was about to emerge from the trees and enter our clearing. I did not hear its approach, of course, and it landed so lightly that I at first thought it was a large sphinx moth. There are plenty of them in our region of Ontario and they have at times blundered into me in the dark. Indeed, if the little owl had not rearranged its feathers, causing the edges of one wing to touch my neck, I would have brushed it away, thinking that it was a moth; but, on feeling the soft touch, I realized that my visitor was a saw-whet owl and once again I marveled at its soundless arrival.

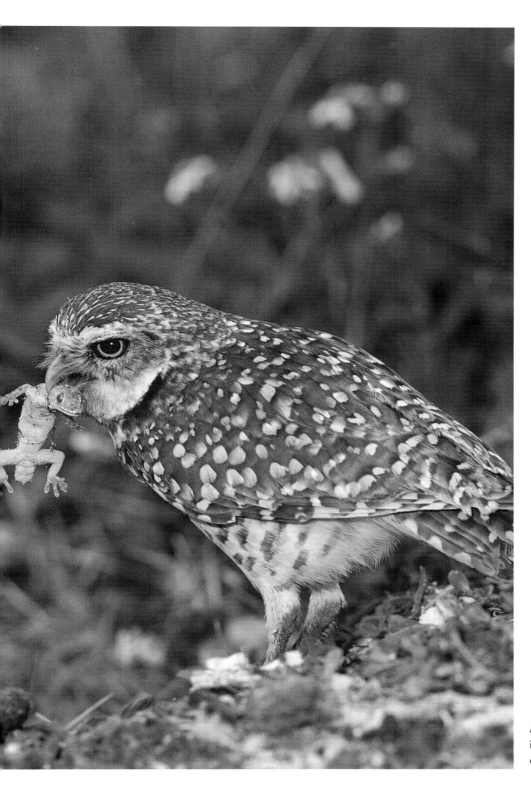

A burrowing owl with a lizard
in its beak. These owls are
often observed hunting at dusk.

The saw-whet remained quietly on my shoulder as I continued my homeward stroll, once again thinking about the many ways that Nature, through elegant and uncountable designs, has ensured the continuity of life on the planet. Nevertheless, as my thoughts turned and focused on the ghostly arrival of the owl, and especially on its landing on my person, it occurred to me that what often means salvation for one animal as often leads to the death of another—a foraging white-footed mouse, for example, is doomed when seen, heard or even possibly smelled by a hunting owl. Yet, although I am fond of white-footed mice (*Peromyscus maniculatus*) to the extent that when they invade our home I set live traps instead of killing them, I cannot begrudge an owl for killing and eating the sleek and pleasant little rodents.

The silent flight of the owls is unique. At some time in the distant past, it was by degrees (and undoubtedly over a **long** period) made possible by a simple change in two feathers: the first primary on each wing, the forward edges of which have become serrated (fluffy) instead of being smooth like those of all other species of birds. During flight, the serrated edges interrupt the air flow over each wing and so eliminate the turbulent noise that is otherwise made by the flight of other birds.

Thus, when the saw-whet landed on my shoulder without so much as a whisper, I was not surprised once I had identified my unexpected companion. Indeed, I was pleased, and not at all taken aback, inasmuch as I felt sure that it was the bird I had been feeding for the past three weeks after it had landed late one evening on the railing of our veranda. Since that time I had put out food every night—raw, boneless chicken pieces—on the roof of a bird feeder, which stands under a huge spruce tree some forty feet from one of the windows of our home.

The owl was a female, as I was later to discover, and she had soon got used to food time, which I had set at 10 P.M. Thereafter, to my

surprise and pleasure, she would allow me to watch her behavior from a distance of about six feet.

Then, two weeks after she had landed on my shoulder, she fed from my fingers for the first time and, from then on, whenever I was late returning from my evening walk in the forest, she would search for me, finding me quickly when her acute hearing picked up the sound of my footsteps, but taking just a little longer when, trying to fool her, I would stop moving on hearing her calls. On those occasions she would evidently rely on scent and vision, but, in any event, she invariably located me, no matter how dark it was, after which she would scold me (or maybe she was greeting me?) with her pleasant, whistled notes. Like all of her kind, she repeated these almost endlessly—the saw-whet's call has been timed at between one hundred and one hundred and thirty times in a minute. It is from the little owl's high-pitched series of *too too too too too* calls that it has derived its name, for the repetitive notes sound as though a large bucksaw is being sharpened with a file.

I had known for a considerable length of time that birds have a sense of smell and that, according to the species, they can detect odors to more or less degree and across various distances, depending on their height above ground, the direction of the wind, the rain or snow and the strength of the odor. My experiences with both wild and captive owls has convinced me that, because the majority of them hunt at night, they have a particularly good sense of smell, although the olfactory acuity of some individuals probably varies, much as it does among humans.

Vision, scent, sound and memory are all important to night- or day-hunting owls, not only because those faculties help them to find their prey, but also because they have to know what amounts to every inch of their range. At night, owls must be able to see obstacles; they must be able to see prey animals moving through the understory or across the open; they must be able to hear such movements; they

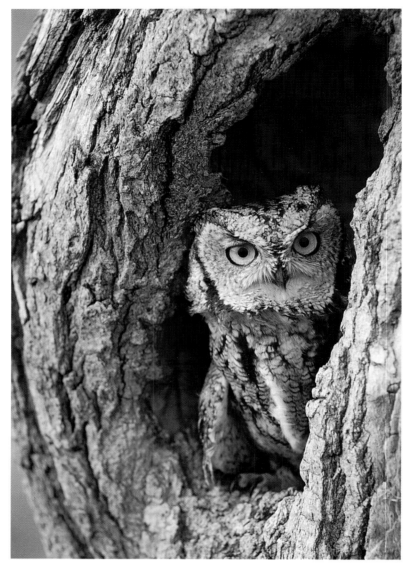

The western screech owl nests in natural cavities and old woodpecker holes.

must, when possible, be able to smell their prey at given distances; they must be aware of predators; and they must remember their flight routes and obstacles such as trees and branches that have to be avoided.

The majority of birds have monocular sight, which means that the left eye sees clearly to the left and the right eye sees equally clearly to the right. Additionally, the visual fields of both eyes can overlap to some degree, allowing for a certain amount of binocular vision. That is particularly the case with predatory birds such as eagles and hawks,

the eyes of which are located toward the front of the head and allow the areas of vision nearest to the upper parts of their beaks to overlap to more or less degree, depending on the species. In contrast, the eyes of foraging birds, such as ducks and geese, or of small insect-eating birds, such as goldfinches and flycatchers, are placed farther back on the sides of the head, allowing for clear fields of vision to left and right, but relatively poor fields of sight straight ahead or behind. The eyes of owls, in contrast, face forward, like those of humans, a position that gives the birds excellent frontal vision, but, also like humans, causes them to turn their heads to left or right in order to see in those directions. And so they do! Indeed, owls can turn their heads so swiftly and so far backward to look over their shoulder that for many years it was believed that they had the ability to turn their heads right around!

Sight in birds and other animals, including humans, is made possible by light-receptive curtains that result from the final development of the optic nerves of each eye and contain two kinds of light receptive cells: cones, which are shaped rather like tiny flasks, and rods, which are shaped somewhat like minute batons. Together, these cells form the outer coat of the retina (the neuroepithelial layer). Cones are particularly sensitive to light, while rods are especially sensitive to darkness. Thus, the eyes of diurnal birds contain an abundance of cones and relatively few rods, while the eyes of night-hunting owls have an abundance of rods and relatively few cones. This is not to say that day birds cannot see at night, or that night birds cannot see by day. A duck disturbed during the night manages to fly to a new location without difficulty, and a nocturnal owl disturbed during the day can fly, also without difficulty, to another perch. Nevertheless, diurnal birds are somewhat handicapped by darkness, while nocturnal owls are somewhat handicapped by daylight.

All owls have excellent hearing and are able to locate the source of sounds accurately, but those owls that hunt at night have exceptionally

acute hearing and can pinpoint the location of even the faintest noise. In fact, when an owl hears a sound during a quiet night, it can almost immediately find its source, being able to locate a mouse or a hare—depending on the species of owl—within one to two degrees of the target, whether the sounds of an animal's movements come from a level or a vertical location. Then, too, when sound comes from one side or the other, an owl can determine whether the prey is on the right or on the left in accordance with the time that the sound takes to reach each ear independently. However, if the noise reaches an owl from a location directly ahead, there is no difference in the time that has elapsed when the noise is first noted, and the owl hears it with both ears simultaneously. Thus, when searching for prey on a dark night, an owl tends to move its head from side to side, listening for the movement of prey animals, and relying more on its hearing than on its eyes, albeit that vision is used simultaneously and, especially, in order to avoid obstacles that may be in its flight path.

In relatively recent times, biologists conducted a study to measure the hearing sensitivity of barn owls in order to establish whether or not owls can hunt by sound alone. During the experiments, individual owl subjects were placed in completely dark, soundproof rooms. No level of light was allowed to enter the experimental chambers. After a number of tests, the experimenters reported that barn owls are definitely able to capture prey by sound alone. The study clearly established that these owls have extremely acute hearing. Only under extremely rare conditions, though, would a forest night become pitch black and, certainly, would never be soundless. In addition, it must be supposed that live animals, such as mice, were used as baits to attract the hearing of the owls. The resulting report did not consider wether owls have a good sense of smell. It seems to me that, under the circumstances of the tests, the owls must have heard *or* smelled the bait, and therefore could not have been said to capture the prey by sound alone, especially if a mouse remained immobile.

During a stormy or windy night, an owl is unlikely to hear the movements of prey, if such should be moving. Under those conditions owls are more likely to remain on their perches or within the shelter of a tree cavity.

It hardly needs to be said that owls and all other birds do not have teeth. Instead, they have specialized beaks and claws that, according to the species, serve to grasp and tear up prey, to crack open seeds, to pluck fruit from bushes or to snap up insects. Since they are unable to masticate, however, the majority of birds must use part of the alimentary canal, the proventriculus, to obtain digestive enzymes that help the gizzard—the muscular section of the stomach that is lined with horny ridges—to break up the food, which is thereafter moved down into the long intestine to complete the digestive process.

Owls, however, lack a crop as well as a gizzard. Instead, depending on the species and the size of the prey, an owl either will swallow small animals whole or will rip apart large prey together with fur or feathers. In either event, the food will travel down into the cecum, the large, blind gut; later, the undigestible parts are regurgitated in a compacted, felted mass known as a pellet or casting.

During the past twenty years, I have gathered owl castings, which I have carefully taken apart in order to determine what the birds have been eating. The easiest to find were those cast by the saw-whets, for these little owls can be quite tame. Over time, I have recovered from their pellets the bones and fur of the following: bog lemmings, flying squirrels, white-footed mice, house mice, shrews and a variety of nocturnal flying and crawling insects, including moths and beetles.

The hunting behavior of owls is based on killing as quickly as possible, otherwise the mammal or bird that is the focus of the attack could escape, or even injure the hunter. For those reasons, when an owl strikes and captures prey, it immediately seeks to immobilize it with its talons and is helped by the fact that it can turn the outer toe

on each foot backward or forward. Helped by its efficient feet and claws, the owl next seeks to quickly sever the neck vertebrae while at the same time, if possible, it crouches with wings spread over the victim, somewhat like an embrace. This stance, which is referred to as "mantling," may help to reduce the prey's struggles and may also protect the kill from thieves.

Owls are monogamous. During the mating season, after the egg-laying, during the long incubation period and the feeding and care of the owlets, a male owl must work hard to provide food. First, of course, he must feed his mate while she is sitting on the eggs. Later, when the young hatch, he must find food for the female as well as for the owlets. With some owls, feeding mother and young is not too big a problem if the usual clutch consists of only two or three eggs, such as are laid by the great horned owl, but with other owls, and especially the snowy owls, the male must work very hard, for a female snowy may lay as many as fifteen eggs.

In the majority of birds, as well as in mammals, the males are usually larger than the females, but with owls the females are larger—or at least as large—as their mates. This characteristic, which is also found in eagles and other birds of prey, is referred to as *sexual dimorphism* and there is ongoing debate about it. To date, a considerable number of theories have been put forth by bird biologists, some of which may well be on target, while others are simply stabs in the dark, such as the one suggesting that owl females became larger because they would then be better able to protect themselves from aggressive males—*if*, that is, male owls during the very distant past had made a habit of beating up their partners. The theory further suggests that over evolutionary time females recognized that it was safer to pair with smaller males. But such a theory, while suggesting that male owls would be likely to attack smaller females if such existed, does not account for the physical development of females.

Another theory, which I believe may be more on target, consid-

ers that females must be larger because they need more physical reserves in order to develop eggs. Then, my own theory is that a larger female will be better able to feed her young and herself if the male should die or be killed.

Between spring and autumn, night-hunting owls sometimes store surplus prey for short periods, perhaps for one or two days, but they usually eat it before it goes bad. In winter, however, saw-whet, great horned, snowy and boreal owls who have made several successful hunts, have been known to store the extra prey, which of course freezes, for some time. Now, one would think that for a small owl like the saw-whet, or even for a large owl like the great horned, frozen meat would be hard to tear up and swallow. And so it is. But the owls have found a way around that problem, a simple way: they fluff out their feathers, cover the frozen prey—as though they were sitting on eggs or owlets—and thaw it with their body heat. But that is only one benefit of plumage.

On average, feathers make up between 7 and 10 percent of a bird's weight. It has been estimated that a saw-whet owl is covered by between five thousand and seven thousand feathers, a hummingbird by between eight hundred and one thousand feathers, and a goose by between twenty thousand and thirty thousand feathers—and whoever took the time to count them all deserves a monument!

Owl feathers are relatively soft for quiet flight, particularly the feathers that cover the body, and the feathers of the majority of owls are varicolored, dappled with tones of gray, black, rust and brown, according to the species.

Not all owl feathers are alike, however. The stiff shafts of the contour feathers that form the surface plumage of birds, especially the wing and tail feathers, are flexible, but strong. They act as airfoils and are designed to offer resistance to the air through which they are moving. The lower, bare part of a feather's shaft, the quill, is embedded in a socket (follicle) of the skin. Each side of the remaining shaft,

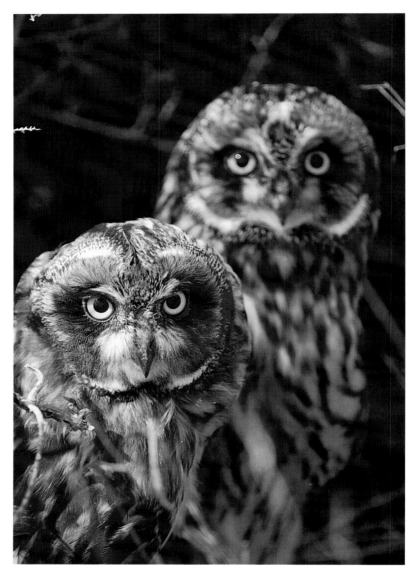

Like many owls, the short-eared owl is multicolored, streaked with tones of buffy-white, brown and black.

the rachis (axis), supports a complex web referred to as the *vane*, which runs diagonally out from the rachis. Greatly magnified, it is possible to see the countless parallel barbs that run diagonally outward from the feather's axis. The barbs themselves carry parallel barbules (minute hooks), more than one million of them on one feather, which run outward from *their* shafts. In effect, the barbs and barbules act somewhat like zip-fasteners and keep the feathers flat and functional; if a plume's barbules happen to be disrupted, a bird can quickly repair

the damage by drawing its beak over the split in the feather's vane. Down feathers, on the other hand, have barbules, but no barbs, perhaps because they lie under the protection of the contour feathers and are located close to the skin. Fluffy and light, all the plumage provides an owl with insulation against cold or heat.

During flight, muscles that are attached to the walls of a quill's socket raise, rotate or lower the feathers, or, when a bird is stationary, the muscles can fluff out or sleek down the feathers. Then, too, feathers, like clothing, protect a bird from the rain and sun as well as from injury, and it is for such reasons that birds preen themselves.

Owls, like most other birds, have a preen gland on their rump located at the base of the upper tail feathers. This gland, shaped somewhat like a large pimple, furnishes oil. First using its beak to squeeze the oil out of the gland, a bird then spreads it over the feathers, repeating the task again and again, until it is satisfied that it has waterproofed and arranged all of its plumage. Apart from protecting the feathers, the oil appears to control the growth of fungi and to inhibit bacteria. Preening also preserves the feathers and through insulation helps regulate the body temperature as well as maintaining the gloss and surface structure of the beak.

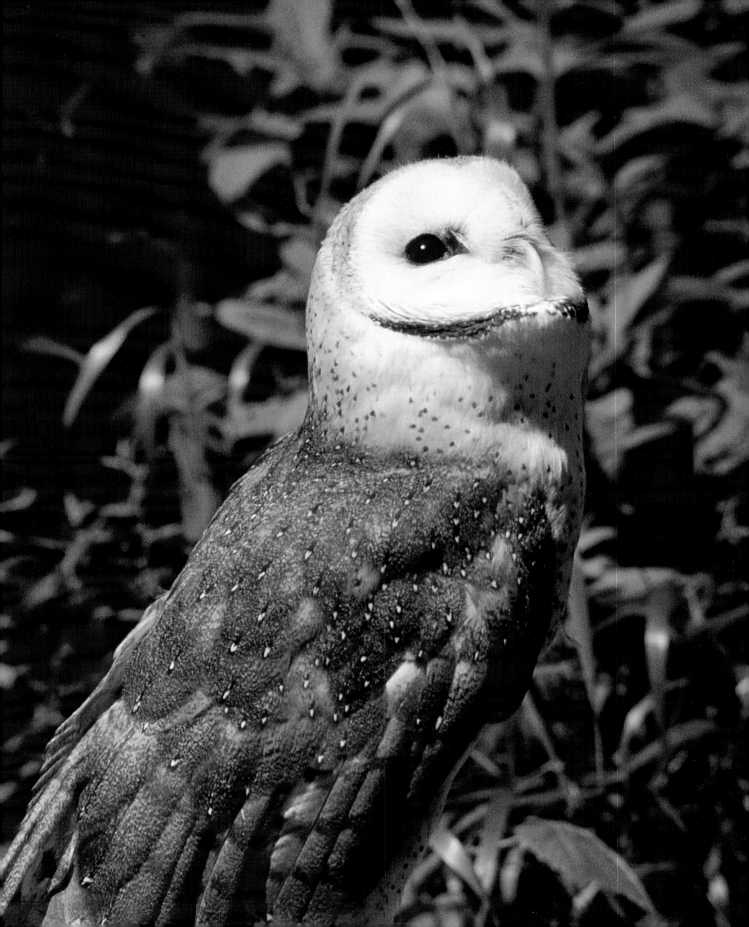

THE ANCESTORS
OF OWLS

The earliest known bird, *Proto avis*, was discovered in 1986 among 225-million-year-old Upper Triassic rocks. The creature, which lived in the tropical forests of what was to become west Texas, was about the size of a chicken, exhibited a number of dinosaurial features and was evidently a contemporary of the earliest dinosaurs known to date. *Proto avis* had "fingers"—three strong, curved claws—on the forepart of its wing. It had long wing bones, a very long bony tail—an extension of the spine—and a beak that was shaped rather like a snout. It also had a wishbone and a shoulder girdle very similar to those of modern birds.

Disappointingly, no feathers were found with the fossil, but bumps on the forearms and "hands" suggested that these were probably the locations to which feathers had been attached. The discoverer of the fossil, Sankar Chatterjee of Texas Tech University, surmised that the bird had been a weak flier.

In 1860, 126 years before the discovery of *Proto avis*, the European scientific community became all astir at the news that the

Opposite: **The common barn owl is the only species of the *Tytonidae* family in North America.**

clear impression of a feather had been found in Bavaria at a slate quarry near Solnhofen, a town north of the Danube. The excitement stemmed from the fact that the slate was 150 million years old and, since the impression was sandwiched between slate, it had to be at least as old as the material in which it was found. Apart from that, the discovery appeared to establish that at least one kind of bird had evolved from dinosaurian ancestors. Most biologists, being as cautious then as they are today, were excited by the find, but perhaps working on the principle that the impression of one feather does not a bird make, and inasmuch as only a few people had actually seen the impression, kept their council. One, however, went public. This was Dr. Hermann von Meyer, who described the feather impression in the *Jahrbuch für Mineralogie* (*Annual of Mineralogy*) and named the bird that had dropped a feather *Archaeopteryx lithographica*—in Greek *archaeos* means "very old," and *pterinos* means "feathered." But owing to the fact that only the impression of the feather had been preserved, and because a number of influential skeptics wondered if the impression had been made by a skeletonized leaf, the discovery could not be considered proof of the existence of birds during the Jurassic period.

Just one year after the discovery of the feather's impression, however, all arguments ended when the clear impression of the bones of what was unarguably a bird were found in the Ottmann quarry in Langenaltheim, which is located about one hour's walk from Solnhofen. There were the clear impressions of a bird's legs with foot attached on one leg, but missing on the other; there were the impressions of the feathers of two wings, each sporting three claws on the "hands," and of a long, bony feathered tail, which was the extension of the spine; but the impressions of portions of the body as well as of the head were missing. The bird had evidently been about the size of a pigeon.

Lastly, in 1877, as though to put the icing on the cake, an almost complete fossil of an Archaeopteryx was found sandwiched by a slab of slate in a quarry near Eichstat, which is located at a relatively short

distance from Solnhofen. Apart from the fact that a few small pieces of the fossil were missing, the remainder of the 150-million-year-old bird was intact. It featured a feathered tail that was long and jointed, the feathered wings were virtually intact, and each "hand" was furnished with three sharp claws, although the first and second of these were fused together. The legs had also been feathered. Around the base of the neck there was a collar of feathers, but the rest of the neck appeared to be naked, although later it was decided that it had probably been covered by reptilian scales. The head was somewhat ducklike and the jaws were filled with small, sharp teeth that virtually filled the mouth. The bird was about the size of a pigeon. Its short wings suggested that it was a somewhat inefficient flier that probably fed on insects, tree leaves and fruits.

Scientists surmised that Archaeopteryx was cold-blooded, but that having in the course of time turned almost all its reptilian scales into feathers, it prospered, wrapped in its warm coat, while most of its naked contemporaries, the true dinosaurs, were killed off by the cycles of cold that occurred at various times.

However that may have been, it seems reasonable to assume that because it lacked the deep keel of the true birds and therefore must also have lacked the powerful wing muscles that are attached to that keel, the feathers on the Archaeopteryx's short wings would not have allowed it to soar; rather the wings probably allowed the bird to take short hop-flights, rising perhaps only a foot or two off the ground. Seemingly, it used the claws on the front of its wings to scramble through trees while foraging.

When dinosaurs eventually died out after reigning on earth for at least 150 million years, their demise made possible the evolutionary development of birds. The front-runners were evidently *Proto avis* and Archaeopteryx, and they probably gave way to all modern birds.

Apparently, however, Archaeopteryx left behind a close relative that is still alive today, a unique bird that as an adult is an odd-

looking creature and as a chick carries hooks on its wings, climbs trees like a clawed mammal and swims like a fish. I had read snippets about this bird and had seen a photograph of adults of the species, but I never expected to actually see one.

Then, in early spring of 1960, I undertook a five-week exploration journey in the jungle country of Venezuela, a trip that began with a guide and canoe at the town of La Paragua (The Umbrella) and continued soon afterwards as my guide and I paddled south while following the upstream course of an unnamed tributary of the Orinoco River, a winding waterway, which a month earlier, swollen by the runoff from the Sierra Parima, would have been impossible to navigate with the rather aged eighteen-foot canoe in the bows of which I kneeled, plying an equally aged homemade paddle.

The trip, which in due course would be partly paid for by newspaper and magazine articles, was nevertheless prompted purely and simply by curiosity. I wanted to observe at least some of South America's tropical mammals, birds, insects—and there were a goodly number of those—and the jungle itself, the hot region where tall deciduous trees spread constant shade on the forest floor, but do little to cool the traveler. Several years earlier I had spent time in the jungles of Brazil, and now I found myself making comparison between the two habitats, finding almost immediately that the Venezuela silva was far more forgiving than the thick and steaming jungles of Amazonia.

My guide, Teofilo Gavilan, was short and stocky, a nut-brown man in his late thirties who had fished the river since he was old enough to use a paddle. He knew the waters well, he explained in Spanish soon after we had pulled away from the rickety dock that served the little community. Then, evidently determined to prove his knowledge—and clearly delighted that I could speak his language— he began to describe every turn of the river and every large tree or rock that we approached, a running commentary that after more than

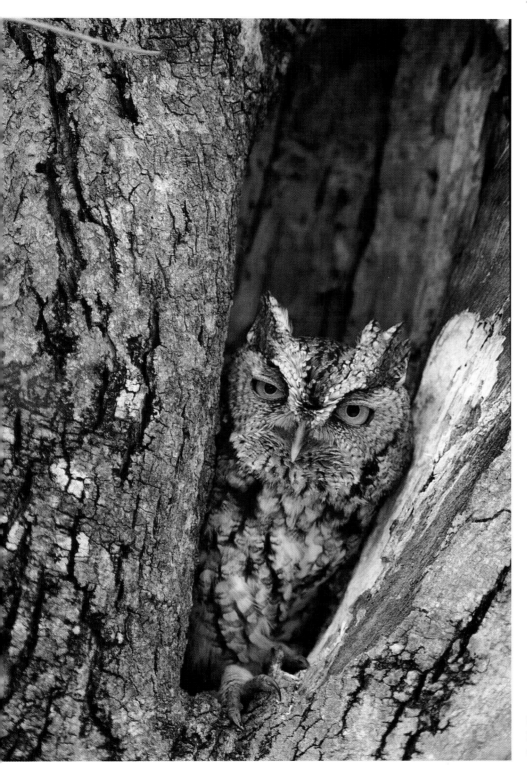

Screech owls are among
North America's smallest birds
of prey.

two hours caused me to explain that I was a *naturalista* intent on seeing as many birds and animals as possible. Thus, although I enjoyed his commentary, I emphasized, tongue in cheek, that when studying *la biologia* I made it a rule to watch without talking; else the birds and *los animales* would fly or run away.

Although a little crushed, Teofilo appeared to understand, and from then on we traveled quietly, albeit when we landed in early evening and set up the camp, my companion made up for his silence by telling me the story of his life as a fisherman, hunter and tourist guide. One night while we were sitting inside the dilapidated tent that Teofilo had furnished, and drinking surprisingly good coffee after eating an indifferent supper, my companion asked if I had ever seen a swimming bird.

Inasmuch as we had seen numbers of ducks and other waterfowl on our way upriver, I was at a loss to understand.

"Yes, of course," I replied. "We've passed quite a lot of ducks since we left the dock."

"No, no, señor!" Teofilo said, laughing. "I mean the bird that when it is small climbs in the trees and dives into the river. A brown bird, like chocolate it is, without feathers, but wearing a kind of wool instead. And it has claws on its wings, señor!"

I was both astonished and delighted by the news, yet I was somewhat skeptical. In truth, despite the photograph I had seen of the bird, I did not quite believe that it existed. Nevertheless, I *had* hoped to get a glimpse of one or more of the adult birds, *Opisthocomus hoatzin*, to give them their scientific name, but if I could actually see a chick diving and swimming it would be a bonus. Despite Teofilo's assurance that the bird lived in that region, I remained doubtful and I tried not to think about it. I could not banish the thought altogether, though!

The hoatzin, I kept telling myself, is clearly a close relative of the Archaeopteryx. It appears to be the only prehistoric species that has

survived mostly unchanged to the present time, unless, of course, one considers the early owls, which are believed to have emerged about eighty million years ago.

Teofilo boasted that he had seen many hoatzins. But once I pinned him down, he admitted that during the nine years that he had been traveling the river he had only seen two chicks swimming, each in a different location, and four adults perched in trees. Two of the adult birds had been together, the others had been alone. Teofilo then told me that hoatzins were hunted for their plumage, which was sold to tourists for *mucho dinero* (lots of money).

Unbelievably, and only five days after Teofilo mentioned the hoatzin, I did see a chick! We disturbed it while it was scrambling along a bare branch. It was somewhat smaller than a half-grown bantam chicken, was covered in brownish, fluffy down and appeared to be rather clumsy. Yet it was fast! In a twinkling it had scrambled along the branch until it was over the river, then it dived straight down and disappeared under the water.

"As I tell you, señor! It has gone into the mangroves. If we stay quiet, it will come out and climb a tree," Teofilo said in a loud voice.

I hushed my guide, telling him not to make a sound until I gave him permission do so! Then I set the timer on my watch and we waited. Twenty-six minutes later the chick emerged. It bobbed up like a cork and, sculling with its wings and no doubt kicking with its quite large feet, swam easily to the far shore. On reaching a gnarled, scaly tree that was about two feet in diameter, it began to climb, making relatively slow but definite progress with its "hand" hooks and, from what I was able to see through the binoculars, with the long, sharp claws of its feet. After eight minutes, I lost sight of the fascinating chick among the branches and leaves of the tree's canopy, but I continued to hear it as it progressed into the crown of the tree.

As matters turned out, although I did not see the chick again, I did get a short look at one of its parents. Through the binoculars I

had an excellent view of an adult hoatzin. It was about the size of a domestic hen, but appeared to be somewhat chunkier, had a long neck and a number of long, tan-colored feathers rising over the back of its head. This untidy plume began just above the bridge of the bird's relatively short, heavy beak. At first the hoatzin had been looking away from us, but after some moments it turned its head and seemed to be staring directly at me, giving me a chance to see one of its eyes, which seemed to glow ruby red, although the light could have intensified the color.

From my position I could see only one side of the hoatzin's face, but I was especially intrigued by the bird's featherless, light-blue cheek patch, which was accentuated by a distinctive ear hole. I was also able to see the bird's feet as they gripped the branch; they were equipped with long, curved and very sharp claws.

After a while the hoatzin, clearly unperturbed, climbed slowly into the green canopy and I did not see it again. I was awed by the experience. Had I just seen the living ancestor of the owl? Indeed, of all birds? I had no answer to that question, of course, and in all probability there never will be.

That night, while I was jotting down the hoatzin's details by the light of a kerosene lantern, and Teofilo was brewing some more coffee and at intervals telling rather tall stories about the hoatzins he had seen in various places along the river's banks, an owl called. The loud, deep *hoos* immediately identified the great horned owl, which must have been sitting in a tree that was relatively close to our camp. I was delighted, and I listened intently to its next calls: *hoo hoohoo hoo hoo hoohoo-aah*, but when I turned to speak to Teofilo I found him actually cowering. He was crouched near the lamp, covering his head with his hands and muttering, *la lechuza viene, la lechuza viene* . . . (the owl is coming, the owl is coming).

I was astonished! To pacify him, I gave him a shot of brandy, but although he stopped lamenting and holding his head long enough to

gulp down the spirits, he muttered a number of imprecations every time the owl called.

I gave him more brandy. He gulped it down. About half an hour later, and despite the fact that the owl continued to call every now and then, Teofilo settled down to some degree and was able to tell me why he was afraid of the owl.

"Owls are evil," he said. "When a woman is having a baby and the owl calls, the baby has trouble. Sometimes the baby dies inside the mother, or it may be born with evil in its heart and has a purple stain on its face that can't be scrubbed off."

By that time the owl had stopped calling. Perhaps it had gone, but I was left wondering if my guide was going to have a fit every time an owl hooted! I need not have worried, however, for Teofilo went to his pack, dug in it for some moments and fished out a dried bird's wing.

"Is good now, señor. I have the *lechuza*'s wing. It can't hurt me now," he said, holding it out to me.

Examining the dried and bedraggled appendage, it looked as though it had belonged to a barn owl, although I could not be sure of my diagnosis. Of a certainty, however, the wing had been taken from a large owl; either from a barn owl or from a great horned owl, two of the four species of owls known to live in that part of South America. Of the four, the ferruginous pygmy owl and the burrowing owl could be immediately eliminated, for the great horned and the barn owls are large while the ferruginous and the burrowing owls are small. In fact, the burrowing owl does not live in tropical jungle regions, being a bird of open spaces.

Two days after the owl episode, while we were paddling across a section of river that had been carved into a fairly large, deep pool, we saw a female alligator that appeared to be resting on the left shore. On going closer, however, I realized that the animal was lying beside a nest mound. Intrigued, and wanting to get a good look at the nest, I

asked Teofilo to steer toward her, but not to attempt to nose the canoe on the shore, for I did not want him to panic—which was something that my guide would have been likely to do.

The alligator did not immediately change her position, but as the canoe got closer, she began to show signs of concern. Whereas at first she had been lying peacefully beside her nest with her snout resting on the shoreline, she soon raised her head as we steered toward her side of the river. Almost immediately afterward she shuffled forward until her nose was over the bank while her tur-reted eyes glared at us with what I can only describe as a cold and calculating look.

As it was, Teofilo was distinctly nervous, so after watching the crocodilian through the binoculars for some minutes, I let my guide paddle upstream, while I exchanged the glasses for my notebook. In the past I had seen photographs of alligator nests after the young had hatched and the mound of vegetation had thereafter been abandoned, but although I knew that a mother alligator often guarded her nest and could be exceptionally aggressive if approached, I had never been exposed to such an event and, let it be said, I had no desire to now experience a similar altercation.

While we followed the river, I recalled the fascinating week that I had spent in June 1959 in an isolated part of the Florida everglades courtesy of the United States Fish and Wildlife Service (FWS).

On arrival in West Palm Beach, I had been greeted by two FWS agents who settled me for the night in a hotel and, next morning, showed up with a one-man tent and fishing gear, food, water, a case of beer, a .38-caliber revolver and twelve rounds of ammunition, and an emergency radio. The firearm and walkie-talkie had been added to the list of equipment in case it was necessary to deal with alligator poachers, who were, I was told, "bold and bad." As matters turned out, I had a fascinating week without encountering poachers, or any other human. At night I listened to the repetitive calls of

owls and by day enjoyed the songs of a plethora of birds, watched a friendly family of opossums, and, most satisfying, observed the behavior of an alligator who came to visit every morning and who turned out to be female.

On day seven, my friendly guides took me in their airboat to the place where the alligator had her nest. Two years earlier, the FWS agents had opened up that same alligator's nest during hatching season. While one agent uncovered the nest and counted the clutch of eggs, the other stood guard with a long pole with which to fend off the irate mother. There had been thirty-eight eggs in a nest made of wet moss, broken sticks, rotting leaves and other kinds of forest mulch. The nest itself, I was told, measured 57 inches (145 centimeters) in diameter and was 23 inches (58 centimeters) high. The eggs, encased in leathery shells similar to those laid by turtles, measured just over 3 inches (8 centimeters) in length and 2.25 inches (6 centimeters) in diameter. The agents told me that a female alligator periodically turns over the top part of the nest, which contains rotting vegetation, to provide moisture and heat for the developing young.

Thinking about that Florida trip took me back to the day before I flew home, when I spent the morning listening to an FWS biologist describe the behavior and biology of alligators. The one thing that had intrigued me most about those dinosaurial creatures was learning that their hearts, like those of owls and other birds, have four chambers, each divided into two compartments, whereas the hearts of mammals are furnished with only two chambers. The crocodilian or avian heart functions like a set of two-way pumps: one sucks up oxygenated blood from the lungs into the first chamber and then sends it out to the tissues through the next chamber; the other pump, however, sucks up oxygen-depleted blood from the tissues into its first chamber and returns it via the second chamber to the lungs to be recycled. Based at least in part on the four-chamber-heart evidence, some biologists in recent times have come to believe

that dinosaurs were warm-blooded and that their metabolism was close to that of today's birds and mammals. But, as often occurs among scientists, there are many others who disagree and maintain that dinosaurs were cold-blooded creatures that derived their heat from the sun and became sluggish between sunset and sunrise. If the cold-bloodedness theory should be positively determined in the future, it will probably mean that ancestral owls and the other proto birds were also cold-blooded. If that were to be proven, the next question would be: How did owls, other birds and mammals become warm-blooded?

The fossil record of owls to date is one of the longest so far discovered among all the groups of present-day birds. It extends backward in time to at least the Paleogene period of North America and Europe. Some paleontologists believe it should be set back further, to the upper Cretaceous period. However that may be, it has been relatively well established from recent DNA information that at some time during the Paleogene, between seventy and eighty million years ago, at least two families of fossil owls diverged from the ancestral line.

The earliest to separate is represented by *Ogygoptynx*, which stems from the early Paleocene epoch in North America; the next is represented by the *Protostrigidae*. However, both of these fossil birds are known from a relatively few bones. Under such conditions nothing much can be said about the ancient finds except to note that the prehistoric remains came from very early owls that evidently became separated from the nightjars. The *Caprimulgiformes*, so named because they were once believed to suck the milk of goats during the night, formed another large group of night hunters that today includes the whippoorwills and nighthawks.

It is now evident that relatively early during the evolution of "modern" owls their progenitors split into two lines, the *Tytonidae*, from which emerged the barn owls (subfamily *Tytoninae* genus *Tyto*)

and the related bay owls (subfamily *Phodilinae* genus *Phodilus*) of Europe, and the *Strigidae*, the remaining large group that in North America consists of nineteen species, seven of which are also found in Europe.

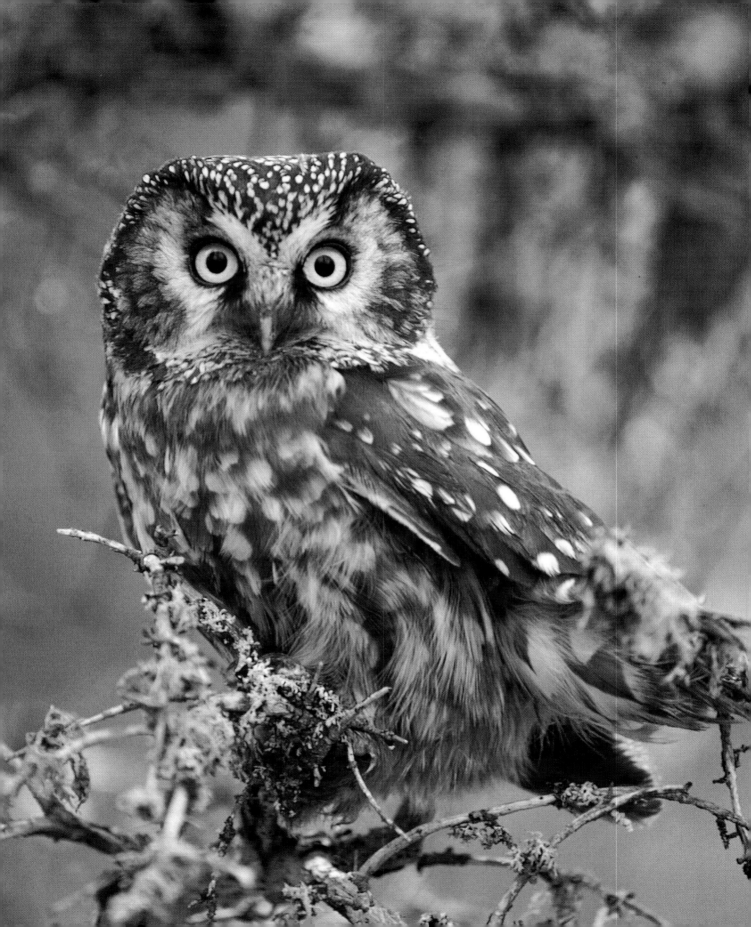

AN OWL NAMED CHUZA—THE BOREAL OWL

y first intimate relationship with an owl took place in Spain in 1933, when as a twelve-year-old I rescued a fledgling boreal owl, *Aegolius funereus* (*funereus* means funereal, for in ancient times it was thought that this was one of the owls that was the harbinger of death). My companion had injured the bird's wing with a BB-rifle pellet.

My parents, one older brother and I lived on the outskirts of the city of Barcelona, Catalonia, in a villa that was located within half an hour's walk from a large, well-forested park—Parque Guell. I had "discovered" it the previous year and had soon got into the habit of exploring it at every opportunity.

The owl's nest was located some fifteen feet from the ground in a hole in a piñon pine. Juan, my Spanish friend, and I had been watching the faces of the owlets for several days when one or another would show itself at the opening of the cavity, but as yet none of the young birds had dared to emerge.

On the fourth day, impatient to get a good look at the owlets, I

Opposite: The boreal owl is named after the boreal woodlands it inhabits across Eurasia and North America.

climbed up the pine and managed to see inside the relatively large hole; but because I had to embrace the tree trunk, I could not feel inside the chamber in order to count the chicks, although I guessed that there were five fledglings in the nest. One of the most interesting aspects of my climb was the odor that emerged from within, a rank smell that resulted from fecal matter and carrion leftovers!

Two afternoons after my climb, Juan and I arrived at the pine tree just in time to see three of the young owls as one at a time they began to emerge from the nest. Gripping the rough edges of the cavity with their already well-developed claws, each owlet slowly transferred itself to a thick branch that emerged from the pine's trunk to the left of, and just below, the nesting hole.

As I was watching the fluffy birds, and of course unaware of my companion's intentions, Juan, who had been "plinking" with his air gun before we headed for the owl tree, aimed at one of the fledglings and fired at it just as the young bird began to flap its wings.

The injured owlet fluttered to the ground and I ran to it. Small as it was, it reared back, spread one wing and partially spread the other, and opened its curved beak while making a sort of hissing sound. I remember that I was somewhat afraid of the display, but on seeing that Juan was preparing to shoot again, I plucked up my courage. Reaching out with both hands, I managed to hold the bird's wings against its body and so lifted it up and held it against me. As I turned, ready to go home and furious with Juan, he laughed. Without thinking, I snatched the weapon away from him with one hand and smashed it against a tree, snapping it in two. That was the end of my friendship with Juan!

Later, I was to find that the pellet had broken the owl's skin at the "elbow" and had bruised an area around the entry wound; but, as my father was to determine subsequently, the bone was not fractured. I made a perch for the owlet in a large, empty garden shed in which I had already rehabilitated (with my father's help) a number of injured birds of various species.

The owl, which turned out to be a female, I called Lechuza (Spanish for owl and a name that was soon shortened to Chuza). She quickly settled down on a diet of dead mice that I trapped, eviscerated and cut up into pieces—for Chuza at first had trouble dismembering a dead rodent. In due course she caught her own mice, of which there were plenty inside the shed.

Having become seriously interested in Nature when I was seven years old, I had for some time been keeping daily notes about a variety of animals and birds I either had rescued or had been able to study from afar, and so, all these years later, I can still recall that Chuza's wing became again serviceable eighteen days after I rescued her. As a fully fledged juvenile, Chuza was striped white and brown with black areas on the head; she had a white face disk, huge eyes ringed by yellow and a yellow beak.

During my intimate contact with Chuza, I learned that owls, contrary to popular opinion, will hunt during daylight, some only when they are hungry, but others, such as the snowy owl, doing so routinely by day or night. I also learned that from a moderate distance owls can recognize by sight humans with whom they have related as fledglings; also, they will respond to calls given by a friendly human and they are able to recognize an individual through his or her voice, whistle or scent.

At the time, however, my knowledge came from observation rather than biological instruction, but, much later, during four years in university majoring in general biology, and afterward, during years of field studies, first in Europe and next in North and South America, I became interested in owls, almost certainly because of my childhood experience. However, as I had learned to do in the past, I did not elect to study one species in isolation of all the others that surround it and which, together, make up the real world of biology.

So it was that during a long wilderness stay in British Columbia where I was largely intending to study wolves, my childhood—and intense—interest in owls was awakened one night in late April, during

a full moon, by the nearby calls of a male boreal owl. I did not at first recognize the loud and repetitive *kree* call, but when I emerged from my tent, it guided me to the caller, who was sitting on a branch of a lodge-pole pine some fifteen feet from my camp and about twenty feet up.

From my early reading, I realized by the call that the owl was a male, and although I was pleased to have his company, I began to get somewhat tired of the repetitive call that, on timing, lasted for between one and two seconds. Then, after a short pause, the call was repeated, again and again and again, and continued in that mode more or less nonstop for eighteen minutes, and then started all over again. That night I got little sleep!

The next morning, field glasses in hand, I walked to the owl tree and began to inspect the trunk, but it was not until I had walked around the pine to the back that I saw an oval-shaped cavity. It was the owl's nesting hole, and if I had wanted assurance of this conclusion, the bird's face suddenly filled the aperture, which I judged to be about 4.25 inches (11 centimeters) wide at the center by some 5 inches (13 centimeters) long. It now became clear that the bird was seeking to attract a female.

The next night, the owl repeated his song endlessly, giving me no peace until the first streaks of dawn arrived. After sleeping for three hours, I moved my camp, placing myself about a quarter of a mile from the noisy Lothario. On the third night I was still kept awake by the repetitive calls, although because they were less noisy, I was eventually able to sleep and, in due course, I got quite accustomed to the shrill love calls, and even grew to like them.

In any event, the owl attracted a female. His calls did not stop, but they became softer, and, according to those who have studied these owls at length, served to lure the female to his "house" as well as to give her some idea of the size of the home territory. In fact, during the third night, the courting couple did indeed fly off, the male evidently showing off his home site. Taking advantage of their depar-

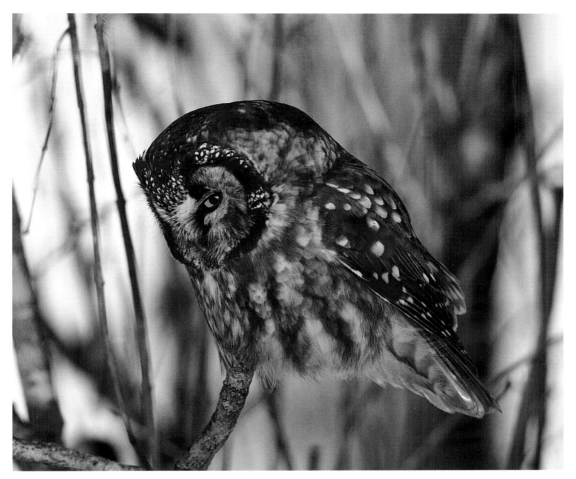

ture, I was quick to scramble up the pine and feel inside the cavity with my bare hand. The nest was unlined except for a number of small bones that "dressed" the inside. I removed three of the bones and later identified them as belonging to white-footed mice. During the next three nights, the owls courted vigorously, calling between matings and flying about quite swiftly, evidently hunting between bouts of "lovemaking."

At the appropriate time, the female, which in most owl species broods on her own, laid the first egg and immediately began to incubate. Thereafter she laid an egg every other day over the next nine days, but I did not count the number of eggs in the clutch until I felt sure that the female had finished laying and had taken off, presumably for

The boreal owl can be distinguished from the saw-whet owl by its larger size and the spots rather than streaks on its forehead.

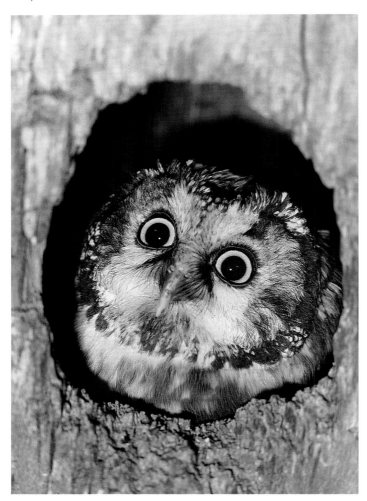

In the breeding season the male boreal owl sings throughout the night to attract a mate to his chosen nesting territory.

a short respite. Then I climbed to the nest and found five eggs.

Although I remained busy researching a variety of animals and plants, I kept an eye on the owl's nest and, of course, I was frequently serenaded at night, mostly by the male. Now and then the female added her voice to his, producing relatively soft, cheeping sounds while on the nest, but at times emerging and joining her mate in a singsong.

I cannot be sure of the exact incubation time for all the owlets, but I believe that the last chick emerged after thirty-two days. Thereafter, although it was evident that the female brooded the chicks, she would emerge from the nest occasionally to join the male for short flights. During these, both birds called, the female's peeping song joining the male's huskier serenade. At times, while watching the nest, if I moved, both owls set up a relatively loud noise by clacking their beaks.

Two nights after the female had started to emerge from her nest for short forays, and both owls had disappeared, I climbed the tree to count the chicks. Three had hatched. One egg had been broken and probably partly eaten, and there was one egg intact, but pushed away into a narrow space at the back of the nest. In order to get the egg down without breaking it, I put it inside my shirt, at the back. In my tent, I examined it. It was fairly smooth, somewhat glossy and

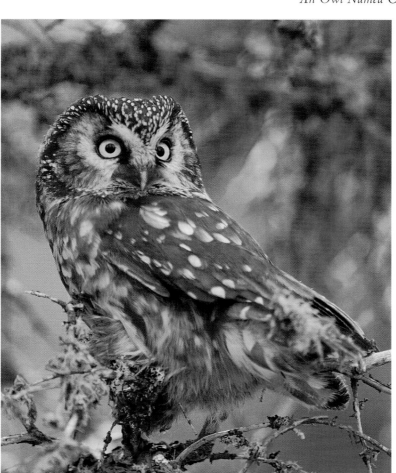

The call of the boreal owl, once called Richardson's owl, is a monotonous *kree* sound.

was covered in tiny, very shallow pits, which are pores for gas exchange and caused me to think that in addition the minute indentations perhaps helped prevent the eggs from rolling out of the nest. The eggs measured 1.25 inches (3 centimeters) long, by just under 1 inch (2.5 centimeters) wide.

When a three-quarter moon appeared late that evening, I stationed myself at a place about twenty feet from the owl's nest and waited for the male to arrive with food for his mate and the owlets. Half an hour after resting myself against a rock, binoculars at the ready, the male glided in, but his descent was too swift for me to identify the animal that he was carrying in his beak. He landed with

his back to me against the tree trunk, evidently gripping the edge of the nesting hole with his claws at the same instant that his mate thrust her head outside, cheeping loudly as the male transferred the prize to her eager beak.

Boreal owls are relatively inconspicuous, even by day, for their adult colors, which are alike in both sexes, are gray-brown in the front and brown-gray in the back. Juvenile boreals are sooty black and have whitish eyebrows as well as white wing spots so that until their first molt they may be slightly conspicuous in daylight. At night, even during a full moon, the boreal is almost impossible to detect. By day, unless it is flying, it is also difficult to see, because, apart from feathers that blend with the tones of the trees and the upper canopies, the birds perch among the branches of conifers, close to the trunk, and remain immobile, striking a statuelike pose.

In North America, boreal owls inhabit regions from the tree line in Canada and Alaska—the southern Mackenzie region, northern Manitoba, northern Saskatchewan, central Quebec and Labrador—southward to southern British Columbia and Alberta. They can also be found in central Saskatchewan, southern Manitoba, northeastern Minnesota, western and central Ontario, central Quebec, Labrador, Newfoundland, New Brunswick and Nova Scotia, and in the mountain regions of Washington, Idaho, Montana, Wyoming and Colorado. As a rule, the boreal owl winters within its breeding range, but may wander southward if weather conditions become severe. The boreal owl is also found in Europe, where in Germany it is known as Tengmalm's Owl. Some of its other favored breeding regions appear to be in Sweden, Finland, Switzerland, France and Spain; in fact, it is widely recognized throughout Eurasia.

MEASUREMENTS

	Female	Male
Wing:	7.2 in / 180 mm	6.8 in / 170 mm
Tail:	4.2 in / 105 mm	3.8 in / 95 mm
Length:	10.4 in / 26 cm	9.1 in / 23 cm
Weight:	6.5 oz / 185 g	3.9 oz / 110 g

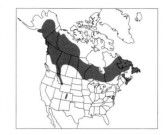

Eggs

Description:	1.3 x 1.1 in / 32 x 27 mm. White, finely pitted and glossy.

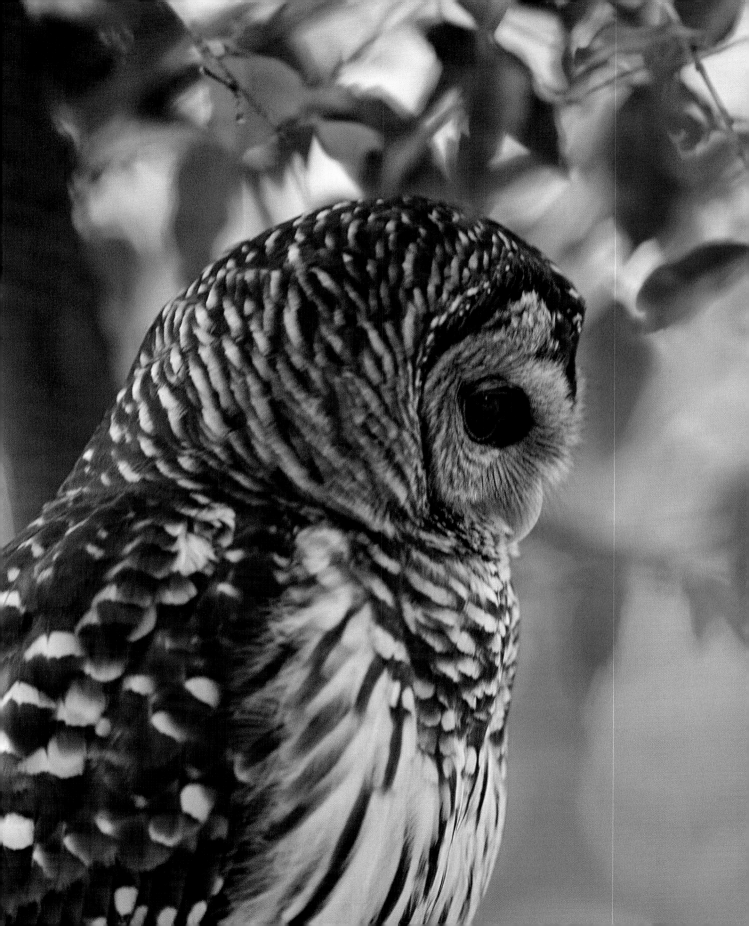

NEIGHBORLY OWLS— THE BARRED OWL

In early March 1974, my wife, Sharon, and I made the acquaintance of a pair of barred owls (*Strix varia*), a sudden and quite unexpected relationship that in due course was to include four partially fledged owlets. During the next four years, the relationship continued with the paired couple and, through four breeding seasons, with four separate clutches of owlets that totaled twelve chicks, all of which left their home once they were old enough to fend for themselves.

Several weeks before we were to meet the adult owls, we had settled down in a lakeshore cabin in a wilderness region that lies about 140 miles north of Toronto, Ontario. The area was quite isolated and consisted of a mix of evergreen and deciduous trees, including some large yellow birches. One of these grew within three feet of our home, was about seventy feet tall and somewhat more than two feet in diameter. It was obviously an old tree and part of its top hamper had rotted away, dropping some large branches but leaving several dead limbs at various levels.

Opposite: **The barred owl is named after the dark barring on its upper breast, neck, head, tail and flight feathers.**

At first, I was somewhat concerned about having such an aging giant so close to our house, so I decided that I would have to take it down. However, as there were a large number of other chores to be done in the home as well as outside of it, for the place had been neglected for a number of years, I kept putting off the chore. In truth, I was nervous about sawing down the tree in case it fell toward the building instead of away from it and, additionally, I did not like the idea of killing a tree that had probably begun its seedling growth some time before I was born. So I procrastinated.

During the first three weeks of our occupation in our only partly refurbished home, I was too busy to pay much attention to the environment that surrounded us, but now and then, when I had to go out at night to visit the outhouse—we did not then have a flush toilet—I would hear the distinctive calls of a barred owl. Its song has been put to words by early ornithologists and sounds something like this: *Who cooks for you? Who cooks for **you** all?* and often ends in a low, sharp *hooo-aah*.

The calls always came from within the shelter of the forest, but not very far from me. I could not, however, determine where the bird was perched, but having heard a number of barred owls over the years, I was not surprised, for although they are friendly once humans have won their trust, when calling in the vicinity of strangers they are shy and will not tolerate a close approach. Their favorite practice is to sit on a branch close to a tree's trunk, a perch where the dark bars on the upper breast and the dark streaks lower down make them hard to detect when they stand quietly, watching the approach of a stranger with their large brown eyes.

One moonlit night some ten days after I had heard the first calls, the owl uttered his chant very near me. He was evidently sitting in a nearby spruce, yet I was unable to see him, despite the fact that he was calling repeatedly. As I listened while trying to find the bird's roost, another owl replied.

The pair called to each other alternately, and it seemed to me that the second caller was near our home. Then, as I was about to return, the male owl flew over my head, almost brushing my hat as it swooped by. It disappeared just as the other bird's calls were repeated, more rapidly now. As I retraced my steps to our home, the more distant calls became louder and, when I reached the cabin's doorway, I realized that the owl, obviously a female, was calling from the big birch tree, from inside a hole in the trunk that was located about twenty-four feet from the ground. The nest entrance was oval in shape, slightly more than 6 inches (15 centimeters) long and about 4.5 inches (11 centimeters) wide at the center. I had noted the aperture when we first arrived, but I had paid it little attention.

One window of our cabin overlooked the nest tree and that night I sat on the floor so as to look up and, with the window open, to listen to the young as the parent birds were feeding them, the event causing a lot of screeching and hissing. While watching and listening, I did some arithmetic. According to the literature, barred owls in our latitude should have begun laying in late March, probably about the 23rd. As a rule, the eggs are laid in unlined nests and only the female broods them, starting to incubate after she has laid the first egg.

Two days later she will lay the next egg, and two days after that she will probably lay a third egg. It is rare for barred owls to lay four eggs and almost unheard of for them to lay five eggs. Thus, an average clutch is likely to consist of two eggs, which are white and smooth and somewhat glossy and measure 1.5 inches (3.8 centimeters) in width by 1.75 inches (4.4 centimeters) in length.

The young peck through the shells after about twenty-nine days. The owlets are downy and helpless and their eyes are shut for the first five to six days, but they are quick to open their beaks and to call for food, which they receive in turn from both parents for the next four to five weeks. After this time they usually leave the nest in daylight to perch on nearby branches and to demand food almost

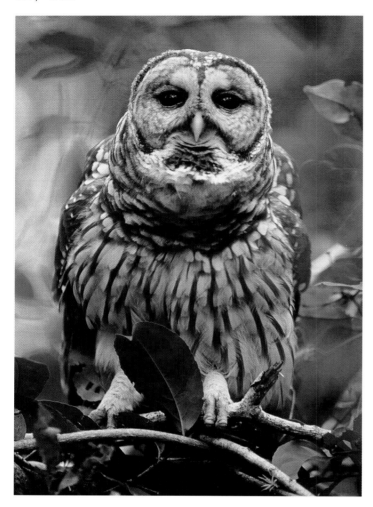

The daytime roosts of barred owls are well hidden in dense coniferous forests, wet deciduous woods, or the mixed woods of wetlands.

continuously from their hardworking parents. At night the young owls may return to the nest, but they are more likely to roost on a branch. Usually, when roosting, the owlets sit in a line and press together. They are preyed upon by weasels, hawks and red squirrels.

Now, on the night of April 15th, I concluded that the owlets would be hatching within the next six or seven days, beginning with the first egg laid by the female and following with the second and perhaps third egg. But I was wrong. The first owlet hatched three days after I had watched the nest through the window. Two evenings later, judging by the commotion, a second chick emerged, and two days after that a third owlet cracked its way out of the egg. At this time, the male became busy hunting by day and night. From what I could see, his major prey consisted of white-footed mice, voles and short-tailed shrews, which he fed to his partner, who in turn ripped pieces off the prey and fed them to the chicks.

One day after the arrival of the third owlet I was unable to contain myself any longer. I got our twenty-foot extension ladder and, to the noisy dismay of the female, who immediately left the nest to join her mate, flying around and calling frantically, I climbed up and counted the chicks. To my surprise, there were four downy, white owlets in the nest, all of whom, instead of showing alarm, sat as

upright as they could and opened their beaks wide, expecting food; and each being ready to grab for it before its siblings.

For the next three weeks the male owl worked *hard*. He took absolutely no notice of Sharon and me when we were outside doing chores, albeit I did refrain from noisy work at that time, for the owl's sake!

However, and against my wife's wishes, for she felt sorry for the male, "that poor hardworking bird," I stood the ladder against the tree one more time and had a last look at the owlets, who, according to my calculations, were probably almost three weeks old. This time, though, the female owl refused to leave the nest, so, being unwilling to molest her, I climbed down and moved the ladder away, getting an "I told you so" from Sharon when I explained my quick descent.

Two days later the female owl left the nest and joined the male in hunting at night and in late afternoon. The owlets seemed to be insatiable, clacking their beaks and hissing loudly as soon as one of the adults perched on the doorway, carrying a mouse or a vole, which, by then, the young swallowed whole.

In due course, the owlets were ready to leave the nest and, led by the largest, they launched, one by one, to land on a horizontal branch of a young maple located about fifteen feet from our cabin. There they clacked and hissed hungrily for all they were worth, despite the fact that the parent birds appeared to be excellent providers. In the absence of food, the young owls preened and showed no fear when we approached them. When they were fully fledged, the young owls left us.

The mated pair, however, remained in our vicinity and continued to use the birch tree as a nest for the next four years. Indeed, they may have continued nesting there for a longer time, but in 1978 we departed for the Yukon Territory.

According to the American Ornithologists' Union, four sub-species of barred owls live in North America:

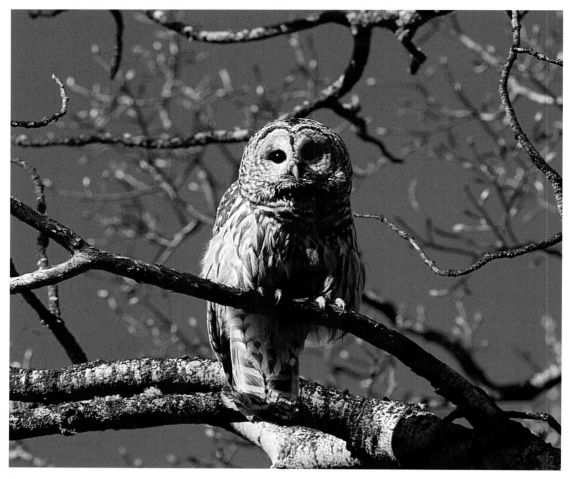

The greatest population density of barred owls in North America is in the southern United States, from Texas to Florida and North and South Carolina.

• *Strix varia varia.* Known in southeastern Alaska, British Columbia and east to Nova Scotia, then southward to the eastern Great Plains, on to Oklahoma, and eastward to Virginia.

• *Strix varia georgica.* Central Arkansas to eastern North Carolina, then south to Texas and on to southern Florida.

• *Strix varia helveola.* Southern and central Texas.

• *Strix varia sartorii.* The central plateau of Mexico from Durango to Oaxaca.

A near relative of the barred owl is the tawny owl of Europe, *Strix aluco,* which is found in many European regions, including Germany, Belgium and France. Yet another related species, the fulvous owl (*Strix fulvescens*), is native to Mexico and Honduras.

MEASUREMENTS

	Female	Male
Wing:	14 in/350 mm	12.8 in/320 mm
Tail:	10.2 in/255 mm	9.2 in/230 mm
Length:	9.1 in/23 cm	8.3 in/21 cm
Weight:	32 oz/905 g	25 oz/714 g

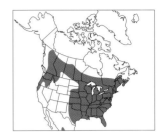

Eggs

Description:	1.9 x 1.7 in/49 x 42 mm, almost spherical at times. White, smooth and glossy.

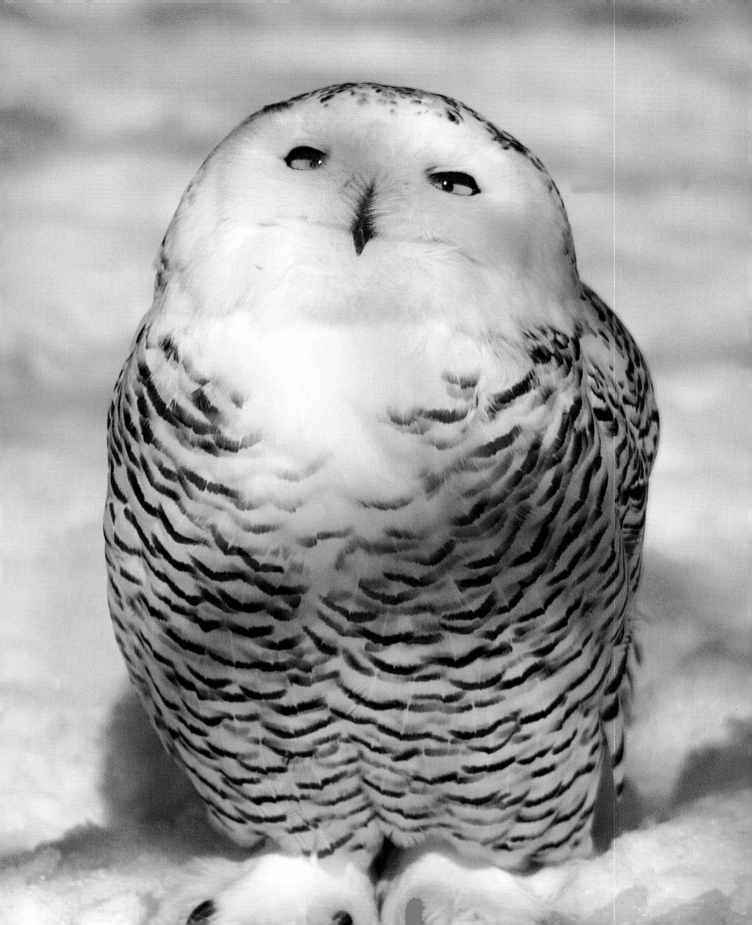

CHAPTER FOUR

THE SNOWY OWL

Some years ago, on a late morning in early March, I got a call from the desk sergeant of a local police department, who, having read some of the nature columns that I had been writing for various newspapers, asked me if I could come to the station to take charge of "a big, white owl." The owl had bitten a small dog and had also chewed the finger of the policeman, who, responding to the frantic call from the homeowner into whose yard the bird had landed, "arrested" the owl after it pecked his finger when he tried to pick it up.

Inasmuch as in those days I had an office in a nearby community, and was also in the habit of carrying in my station wagon cages, catchpoles, several live traps and a small tape recorder, which I kept handy to record the details of those animals that I was asked to rescue and rehabilitate, I responded to the call, arriving at the police station half an hour later.

"Glad you could come," said a very large policeman whose right index finger sported a bandage.

Opposite: Its densely feathered coat protects the snowy owl from the rigorous cold of its arctic habitat. Even the owl's legs and feet are feathered.

Then, ushering me toward the cells, he began to explain.

"I don't know what kind of bird that is. I never seen one like it, but it's real vicious! An' it's big. An' the beak almost tore off the end of my finger. I had to throw my coat over the thing to pick it up an' then I had to call for another car 'cause I couldn't drive holdin' the damn bird, an' my finger bleedin' an' all! An' it bit the dog's ear, a dachshund, a small one."

Following the irascible constable, I soon identified the "damn bird," a big, handsome, female snowy owl (*Nyctea scandiaca*). She was perched on the back of a chair in one of the holding cells, her intense gaze fixed on us, one wing, the right one, drooping. Despite her injured wing, however, she was a regal bird. Her beak was black, and her lemon yellow eyes bored into my own, as though she was trying to read my mind. Typically of snowy owl females, she was not all white. Her back, breast and tail were heavily barred and spotted with dark brown, while her head, face and shoulders were mostly white, but peppered with small, black dots.

Leaving the policeman standing in the entrance, I entered the cell, slipped a leather glove on my left hand and approached the owl slowly while speaking repetitively, but softly. As I moved forward, the snowy fluffed herself out, extending the left wing—the right merely jerked—and hissed noisily while clacking her beak, displaying a typical threat reaction. I backed away, not wanting to disturb the bird until I could get from my car a suitable container for her.

Seeing me retreat from the owl, the policeman backed away also.

"Is that thing too dangerous? Should we shoot it?" he muttered as I left the cell.

"She'll be fine," I replied. "I'm going to the car to fetch a container for her, then we'll be off."

On my return, the owl was still hissing and the policeman had closed the cell door, but, although I was annoyed with the man, I ignored his stupid behavior. Instead, I placed a roomy wooden box on

the floor, opened the lid, told the policeman to move a hand up and down so as to distract the snowy and, while he was getting her attention, I stepped behind her and grabbed her wings with both hands. Then, having to tug somewhat because she was holding the back of the chair with both sets of talons, I pulled her free and walked around the chair to the box, putting her in it and at the same time holding her down with my gloved hand while I closed the lid.

At home, I decided to place the snowy in a section of the basement that I had prepared three years earlier for the rehabilitation of several injured hawks. The "room," which I referred to as the clinic, was eight feet by six feet. A two-inch-thick round perch, made from a sapling maple, was anchored at each end of the room, near a small window. Beside the perch, I had added a twelve-inch by ten-inch feeding platform secured to the center of the perch. A four-inch hole in the platform held a water container.

My first task, however, was to get the owl out of the box without suffering the policeman's fate. Moving her from the box and placing her on the perch without myself getting injured was going to be tricky inasmuch as I would have to thrust both hands into the container the moment that the lid was lifted. Although I was wearing heavy gloves, the owl's beak and claws were formidable weapons that would almost certainly go through the leather and, whereas my hands would be somewhat protected, I felt sure that I would get a number of deep puncture wounds. Moments later, however, thinking about the snowy's weapons gave me the solution. As it turned out, the problem was a simple one. I merely lifted the box up to the level of the wooden platform and opened the lid. The owl immediately struggled out of her prison, landed on the platform and thereafter hopped onto the perch, facing the wall at first, but quickly turning around to face me. While moving, she did not stop hissing, mewling almost like a cat and clacking her beak; and when she had settled herself on the perch, she crouched aggressively while continuing to make her threat calls

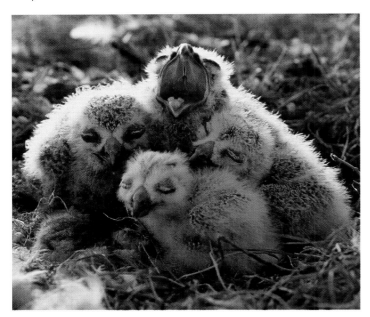

Snowy owl chicks wait on their tundra nest for a parent to return with food.

and spreading her left wing, the right remaining as before.

Feeling sure that she was hungry, I first filled the water container and then drove to the nearest grocery store, which was some ten miles from my wilderness home. There I bought four chicken breasts, two pounds of beef liver, a pound of beef fat and two pounds of chicken hearts. I did not, of course, expect the owl to eat all of my purchases right away, but I did not plan to go to the store every day and so I laid in enough food to last for at least two weeks.

At home, I cut a chicken breast in half and took it to the owl. She smelled the food immediately, and one large, clawed foot "killed" it the moment I tossed it onto the platform. Next she mantled it, crouching, her good wing partially covering the "prey." She hissed at me and bobbed her forequarters up and down while rapidly clacking her beak. I left her to her feast and went to prepare a series of food packages, each containing chicken, beef liver, fat and chicken hearts, all but one of which I put into the freezer. The last one went into the refrigerator, for I was sure that Snowy, as I now thought of her, would be needing more food before the night was over.

For the next hour I sat trying to think of a way to inspect, and hopefully to treat, Snowy's wing without hurting her and, definitely, without having her beak or talons, or both, rip up my hands. Apart from injury to myself, I was greatly concerned for the owl. Yet I found myself almost ready to give up, to let the wing either heal of its own accord or remain as a useless appendage. Then I thought of a way!

Hurrying to my workshop, I took down a roll of electric wire, the kind that is protected by a plastic coat. Cutting off a five-foot length of the white wire, I fashioned it into a noose and attached the end to a four-foot-long stick. My plan was to make a loop that was wide enough to go over the owl's body and on down to her legs. When the noose was below the owl's "knees," I proposed to close the noose and imprison the dangerous claws.

Before that, however, I had to make a hood for Snowy, a sort of bag with a drawstring that covered the head, was fastened lightly around the neck and had a frontal aperture for the beak. My next step would be to bandage the legs together at the "ankles," but the noose was to be left on, the last restriction to be removed after the examination and treatment were concluded.

Caring for a large, injured bird, especially a predator, is really a job for two people, but at that time I was not married, so I had to tackle the task on my own. That meant I had to immobilize the good wing in order to be able to examine the injured one and for a time I could not think of a way to do that job. In the end, I decided I would use a length of elastic bandage and wrap it around the body and over the good wing, leaving the injured wing free.

I put my plans into action that afternoon. Using the noose to secure the legs was easy, albeit that Snowy became frantic when I lifted her off her feet. The placing and tying of the hood was a twenty-minute job accompanied by much hissing and beak clacking, after which pinioning the free wing was simple.

Next, I brought in a chair and turned Snowy onto her back, on my lap, my surgical toolcase at hand. Despite the owl's protests and her immediate attempts to break free, I extended the injured wing. No bones were broken. A moment later I found the cause of the problem. Snowy had been injured by shotgun pellets. Examining the wounds, I removed the first pellet. It had been partially stopped by the wing feathers and had only just penetrated the skin. I removed it with

tweezers, then measured it with calipers. It had a diameter of .10 of an inch, making it a number seven shot. I was thankful for that! Anything much larger would certainly have broken bones.

Continuing the examination, I counted seven holes on the underside of the wing and three in the breast. Four pellets had gone right through the feathers and tendons without doing more than creating four small holes. The other pellets had stopped in the fleshy, upper part of the wing and, despite the owl's jerks, I managed to remove them cleanly. Now I turned my attention to the breast, finding that the pellets had gone in relatively deep, although, using a set of fine tweezers, I was able to remove them. After that I disinfected the injuries with a mild solution of potassium permanganate and decided that Snowy's injuries would heal without the necessity of binding the wing.

One week later, just at the time when Snowy was beginning to trust me to the point where she would take food from my fingers, I noticed that her left nostril was oozing a mixture of blood and an amber-colored fluid that I took to be serum. So, once again, I had to bind her legs and wings. Holding her beak tightly with one hand, I wiped away the bloody fluid with a Q-tip. Then, using a powerful magnifier, I peered up her nose and immediately found the cause of the bleeding—one shotgun pellet had lodged in the nostril! Fortunately, I had in my toolcase one of those very fine tweezers that entomologists use for collecting insects. With the fine-pointed tool, while holding Snowy's beak tightly, I managed to remove the pellet. Next, using another Q-tip, I wiped away the resulting yellowish bloody dribble that emerged from the nostril.

Three weeks later, Snowy was completely recovered and, although she would not allow me to pick her up, she accepted my presence and took food from my fingers. I had grown fond of her, but now was the time to release her to her own world. One last time I had to take hold of her and put her in the box, then I moved her from the basement to

the outside, set the box on the ground and opened the lid. Snowy sat up, her head out of the box. She shook herself, shuffling her feathers, then, with one hop, she left the box and fanned away toward the north, her great wings making a swishing sound as she lofted high and disappeared over the trees.

Two years after Snowy's departure, a second snowy owl came into my care, this time in early May. This one was a male and somewhat smaller than Snowy. He was almost dead from starvation and close to losing both his feet from gangrene caused by the leg-hold trap that held his legs. The trap was small, perhaps intended to catch squirrels and, in one way, the owl was lucky, for when the trap closed, a pencil-thick piece of a branch evidently got caught between the jaws at the hinge level. The bird's legs were held securely, but the bones were not fractured, although blood circulation must have been restricted to some degree.

In effect, I suppose that the owl was twice lucky because not only was he found by a couple who were strolling through a relatively open maple forest, but his location was only about one mile from where I lived, and the good Samaritans, Rob and Elsa Parish, knew that I cared for young and injured wild animals.

However, Rob did not attempt to free the owl from the trap, for he hissed and clacked his beak when approached. Instead, Rob drove to my home to seek my help and then drove me, together with Snowy's old box, to the edge of the forest and thereafter guided me to the owl.

The bird's condition shocked me! He had evidently been a long time without food, perhaps as long as a week, and I was surprised that he was still alive and able to hiss and clack, even though both sounds were feeble. He was so weak that he could hardly lift his head, and apart from his hissing and clacking beak, which were really expressions of his fear rather than aggression, he remained

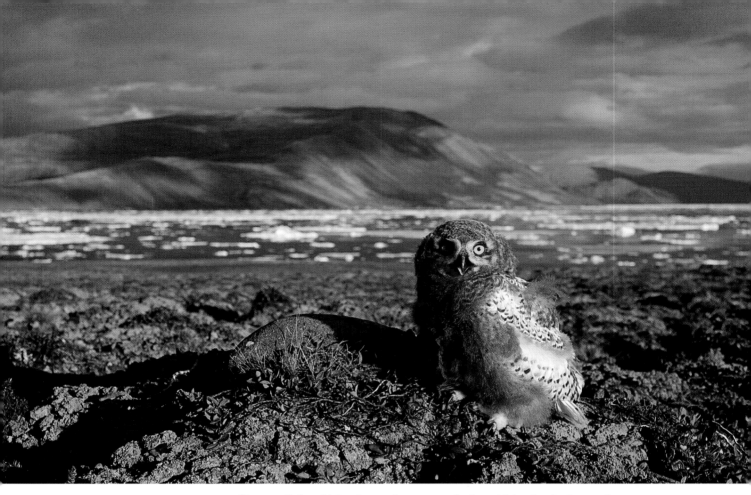

This snowy owl fledgling was photographed on Ellesmere Island, Northwest Territories.

limp as I freed him from the trap and placed him in the box, where he immediately collapsed.

As soon as Rob let me off in my driveway, I literally ran to the house, put the owl in the basement room, which had not been inhabited since Snowy left, filled a large hypodermic syringe with water and hurried back. The owl was so eager for the water that he almost choked, so I had to dribble the fluid into him. When the syringe was empty, he clacked for more—no longer hissing now—but I left him in the box and hurried to the kitchen, where I cut a number of short, thin strips off a small beef roast that was intended for my evening meal. Putting the raw meat in a glass and sprinkling it with water, I ran back to the owl, tweezers in hand.

As with Snowy, the owl smelled the meat as soon as I reached down with the first offering, but although he moved his head, he was too weak to sit up. An hour later, after he had drunk more water and

had eaten eight strips of meat, he was able to lift himself to his "knees" and even managed to lean against one of the walls of the box; that done, his beak opened and was quickly closed on the next morsel of beef. In this way he consumed what I estimated to be eight ounces of raw beef. He would have eaten a good deal more, of course, but, in his condition, feeding had to be done a little at a time and at intervals, although I allowed him plenty of water.

By late evening, Nyctea, as I decided to name him, had eaten well and had consumed a good amount of water. I felt it was now time to examine him thoroughly, especially because he was still weak and, therefore, docile.

First I took him out of the box and laid him on an old rug on the floor. He remained quiet, lying on his side and showing no signs of wanting to stand upright, so I started on his legs. Both "ankles" were scraped, the left one about two inches up the leg, the right one about one inch lower. The skin on the sides of both ankles had been rubbed off, but after a careful examination of the legs I was certain that the bones were not broken, or even cracked. The feet seemed all right, although the bird was not moving them, so I used a pencil to move the toes individually. Then, placing the pencil under the feet, one at a time, I lifted, a movement that caused each foot to clench, albeit slowly.

Although I hoped that I was not being premature, I began to think that the owl would recover.

Next, I applied antibiotic ointment to the injuries of both legs and bandaged them with gauze that was held in place by adhesive tape. Then, one foot at a time, I massaged and flexed the toes, finding that as I worked, the digits began to move on their own; slight as was the movement, it was encouraging, so I massaged the legs, starting at the thighs and working down, hoping to encourage a better blood flow. The wings were next. One at a time, I moved them out and in repeatedly. After several minutes I began to feel some resistance, and

especially if I pulled a wing to its fullest extent and then let it go, it moved back to the closed position of its own accord. Yet both wings remained folded.

That night I had no sleep. Every hour I would visit Nyctea, give him food if he showed interest in eating—which most of the time he did—and exercise the feet and legs and wings. Little by little the owl began to help. First he moved the toes of both feet, spreading them slightly, then clenching them again; and the wings opened somewhat, but on their own, rather like the way an owl squats over its prey and mantles it with its wings. By six o'clock the next morning, seeing some more improvement, I again fed the bird. Closing the box, I picked it up and left the basement. In my bedroom, I put the owl's box on the bedside table and, after setting the alarm clock for 10 A.M., I kicked off my shoes and turned in fully clothed.

Less than three hours later I was awakened by a series of loud, cackling calls that, although somewhat muffled by the box, left no doubt that my patient was awake and obviously hungry and thirsty. Still somewhat groggy from sleep, I swung my legs off the bed, sat up and opened the box lids, whereupon a weak, but obviously hungry bird sat upright, tried to mantle his wings in the confining box and at the same time he sought to bite my fingers, no doubt mistaking them for food.

Nyctea was still tottery and obviously weak, so I left the box lids open when I went to the kitchen to prepare more food for him, this time slices of beef liver that I had prepared the night before. I had hardly left the bedroom when Nyctea, trying to get free, tumbled the box off the table and was himself ejected from his temporary prison.

Going to the rescue, I found the owl crouching on the bedroom carpet, his wings open, but their tips touching the floor, and his feet spread out, the claws gripping the rug. He was tottery, but as I approached him, he raised his neck and fixed his eyes on me and his beak began to clack. He was recovering!

As matters turned out, I put Nyctea in the basement "hospital" and fed him and watered him there from then on. He fully recovered four weeks after he came into my care. On the morning of the fifth week, he suffered one more indignity when I grabbed him from behind, one hand on each wing, and put him in the box, after which I took him into my part of the forest and let him go free.

Snowy owls breed in North America from the western Aleutians, northern Alaska, northern Yukon Territory, Ellesmere Island, the coastal regions of western Alaska, the northern Mackenzie region, southern Keewatin, northeastern Manitoba, Southampton and Belcher islands, northern Quebec and northern Labrador. They feed on such animals as southern bog lemmings, collared lemmings, brown lemmings, voles, birds, and even insects.

Collared lemmings are the only rodents that turn white in winter, evidently because these little mammals breed in the cold regions of North America and northern Eurasia. Their color, of course, blends with their environment, although snowy owls are not often fooled by such camouflage. Nevertheless, collared lemmings are expert survivors and continue to thrive in the intensely cold northern winters. In fact, in 1956, during mining operations in the southern Yukon Territory, the skull and bones of a lemming were found in the animal's nest, which was covered by some twenty feet of soil and boulders. The find was below the snow line, but radiocarbon dating later in Ottawa established that the collared lemming had died in its nest *14,000 years* earlier! Today, collared lemmings are no longer found in that region; it is now too warm for them!

During a shortage of prey such as lemmings and voles in the north, snowy owls head south, hunting from coast to coast in southern Canada and the northern United States. At times, and especially if prey is abundant, some snowies nest and raise their young in southern regions and remain there year-round.

Snowy owls also live and breed in Norway, Sweden, Finland, northeastern Germany and northwestern Poland, and, in fact, right across Eurasia, regions where these owls are almost always made welcome as exterminators of rats and house mice.

As a rule, the courting season begins in early May. The male puts on an aerial display that includes soaring and almost stopping high above the ground with outstretched wings, then closing the wings and diving, only to swoop up once more with rapid strokes so that the bird seems to undulate as he rises, drops and rises again, the while holding in his beak a dead lemming or vole and now and then landing with the prey and mantling it briefly before rising once again to continue his undulating courting performance. All of these displays are performed, of course, for the admiration of the female.

After mating, the owl will probably lay the first egg in early or mid May, after which the others will be laid at intervals of between two and five days, the former being the most likely. Thus, the age gap between the first chick and the last may be between two and three weeks.

Snowy owl chicks emerge from the eggs dressed in white down, a coat that they will retain for the first ten to twelve days of their lives, although the quills of their wings start to emerge one week after birth. About four weeks later the chicks have grown considerably and weigh between 45 and 55 ounces (1300 and 1600 grams). According to A. Watson in his study, the young owls begin to leave the nest between eighteen and twenty-eight days after hatching and scatter in the neighborhood. Now the hen is free and both adults take turns feeding the young.

Fledging occurs between twenty-eight and thirty-two days after birth, but the owlets do not fly well until they are between fifty-five and sixty days old.

MEASUREMENTS

	Female	Male
Wing:	18.5 in / 462 mm	16.0 in / 402 mm
Tail:	10.8 in / 270 mm	9.5 in / 238 mm
Length:	22.8 in / 58 cm	21.3 in / 54 cm
Weight:	77.3 oz / 2191 g	68.9 oz / 1956 g

Eggs

Description:	2.3 x 1.8 in / 57 x 45 mm. White, elliptical, smooth, slightly glossy. Four to 10, maximum 15, but rare.

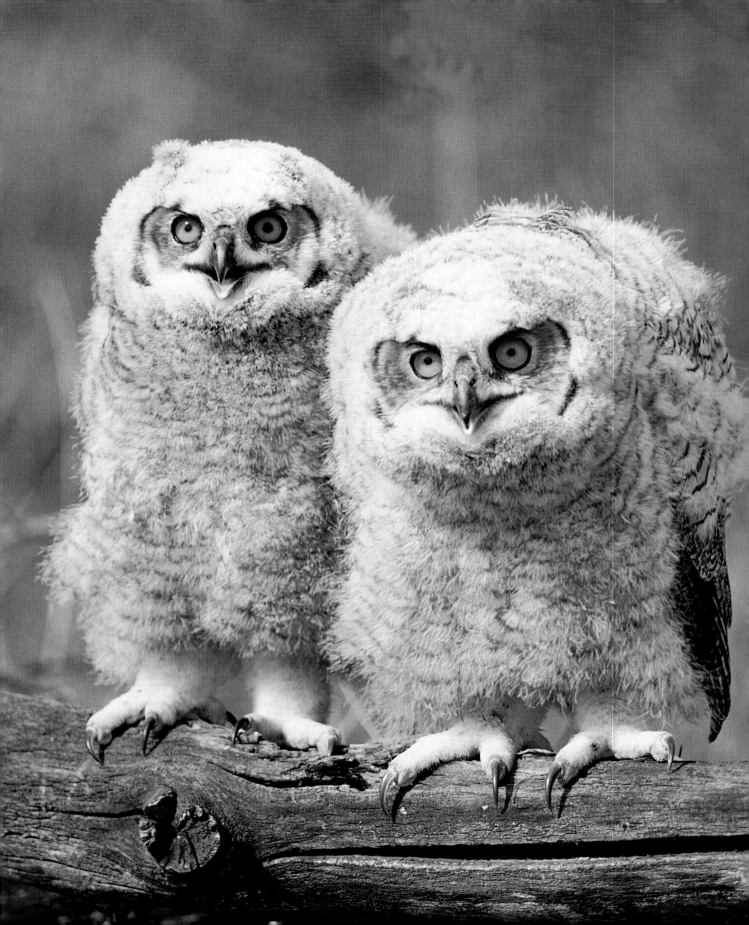

THE GREAT
HORNED OWL

O n three different occasions I treated and released great horned owls (*Bubo virginianus*). The first one, whom I called Bubo, I guessed was a male because of his relatively small size. (Males and females of this species are look-alikes and, except for size, which in any event can be unreliable, require considerable handling in order to determine their sex.) Like Snowy, he was wounded by buckshot, although in his case the pellets were somewhat larger, being number twos measuring .15 of an inch. Unlike Snowy, however, and as I was to learn later that evening, the owl had only received six shots. Two had penetrated the muscle of the right breast, relatively high up under the wing, and four had lodged in the left thigh. None had inflicted a serious wound, but they had brought the owl down. If he had not been hit on the breast, he might have been able to fly away, although whether or not he would have survived from the leg wounds is debatable.

As much as I was able to determine, Bubo crashed either during the afternoon or evening of August 12, 1964, and landed on the

Opposite: **These great horned owlets will fly when they are approximately two months old.**

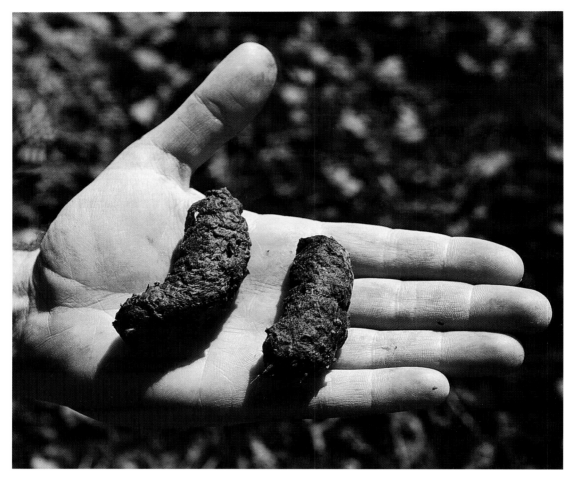

The indigestible bones, feathers and fur of the great horned owl's prey are regurgitated as pellets.

right-hand edge of a county road some time before the arrival of a car driven by Harold Chapman, whose wife, Martha, saw the struggling bird illuminated by the vehicle's headlights and immediately alerted her husband.

"It's a big owl, Hal. And it's hurt!" she exclaimed.

Harold stopped the car a few yards away from the bird, parked, and he and Martha stepped onto the road, then walked toward the injured owl, which was trying frantically to right itself without success while at the same time snapping its beak aggressively.

The Chapmans were avid birders and it so happened that they were on their way home from an afternoon meeting when Martha saw the owl. They immediately felt sorry for the injured owl, being

fond of birds of all species, but they did not know what to do in order to help it, especially in view of the fact that the bird was obviously ready to use beak and claws to defend itself.

As Harold told me later, Martha solved the problem:

"We stood there, watching the owl. He was laid back, sort of propping himself up with his tail and backside and, I can tell you, I was watching the clacking beak and his one leg, which was extended with those big, sharp claws spread and his one wing spread out. I just stood there ..."

"Yes," said Martha. "He stood there like a ninny! So I told him. Go to the car and get your jacket from the back seat and then go and wrap the owl in it!"

Well, that is what Harold did, but having immobilized the bird, he did not know what to do with it. Martha again came to the rescue.

"You hold it," she said to her husband. "I'll drive, and we'll go to R. D. Lawrence. He'll know what to do."

The Chapmans lived on a farm that was some eight miles from my home. Although we were not close friends, we knew each other, and on one occasion they had called me to ask for my help with an infant raccoon whose mother and two siblings had been killed by a car near their property. The "help" I was to give them consisted of my acceptance of the care of the little raccoon, which in due course was released as a young adult on my wilderness property.

In any event, the Chapmans arrived at my home at nine-thirty that night, and while Martha explained, Harold sat in the car's passenger seat clutching a struggling, beak-clacking bird who had defecated all over his coat and, for good measure, had squirted odorous fluids down the front of his rescuer's trousers. And if that was not enough, Harold's arms had almost gone to sleep. What would he have done, he asked plaintively as I took the struggling owl from his embrace, if the bird had got loose? The question remained

unanswered, for I was already walking toward the house, aiming for the basement, where Snowy and Nyctea had recovered.

Followed by the Chapmans, I led the way downstairs. The six-foot-long perch and the feeding and watering platform were still in good shape, although rather dusty. That did not bother me. But I *was* concerned about the owl's ability to move freely with one injured leg, which he was hardly using at all. For that reason, I decided to enlist the help of Bubo's rescuers, an invitation that was not at all well received by Harold.

"What do you want me to do? You can't want me to hold the bird?" he asked.

"I'm afraid so," I replied. "But if you hold the wings with both hands, sliding them downward until you are almost touching the root of the tail, he won't be able to hurt you and I'll be able to bandage the wings in such a way that he cannot possibly get loose. Then you can hold him on his back on your lap and I'll see what I can do with his injuries, whatever they may be."

As matters turned out, I was able to bandage the owl without difficulty, for he was by that time exhausted. Next I tied both his legs together, leaving a long line hanging down between the feet so that Martha could hold the legs out of the way while I examined what at first glance appeared to be an obviously injured wing. So, hoping that no alar bones were fractured, for bird bones are fragile and *very* difficult to repair, we started to care for the owl.

With the Chapmans helping, the examination and subsequent treatment went well. The chest pellets came out easily and quickly, and the round entry wounds were swabbed and covered with antibiotic ointment. After bandaging the wings so the bird could not flap them, I attended to the thigh, and that turned out to be the most difficult part of the treatment, because the legs had to be tied together in order to avoid the great, curved and finely pointed claws. But by pushing the legs up with one hand to a sort of knees-up

angle, and with Harold holding the knees in that position, I was able to reach the wounds. Two of the pellets were just under the skin and easy to remove, but the other two had gone in at an angle and had to be probed for and carefully removed, an operation that took twenty-five minutes.

So, with the injuries looked after, I unwound the gauze bandage, receiving a slap in the face from the owl's good wing in the process. I next picked the bird up while holding both wings against his sides, and Harold, using a pair of long-bladed scissors, very carefully cut off the leg ties. That done, I put the owl on the perch and we backed away, stopping about seven feet from him so as to monitor his behavior.

To my surprise, our patient fluffed out his feathers, hopped one-footed along the perch for a short distance, then turned and hopped back to stop in front of the platform. After some moments he hopped from the perch to the platform, looked at us, and suddenly cut loose with an unearthly scream! I had heard great horned owls call in that fashion, but always at night and when they were not sure about the identity of an object, which might be a rock, a sleeping predator or, perhaps, a snowshoe hare. The entirely unexpected shriek startled me, but not nearly as much as it startled the Chapmans. As one man—as it were—they dashed to the basement door, Harold being not a bit gentlemanly in that he pushed his wife to one side as he was fleeing from the owl, who almost immediately afterward cut loose with another of his banshee wails.

Moments later, as I watched him, he began to adopt a mantling posture, crouching as he spread both wings, albeit the left one was not held out as far as the right. Next he uttered a barklike sound that was short and not very loud. As he was doing so, he began to bob forward and back, head down. Could he be hungry and asking for food?

I left the basement "Bird House," as I had rechristened the makeshift clinic and, accompanied by the Chapmans, I went upstairs

and checked out the food in the refrigerator freezer, finding several chicken legs, some beef liver and two pounds of hamburger. I sawed off about half a pound of frozen hamburger and thawed the meat and one chicken leg in the microwave oven. Twenty minutes later we all trooped down to the Bird House to find the owl sitting quietly. But as soon as we entered, he began to mantle and lower his head once again, until I put the food on the platform, when he immediately lowered his head to the hamburger and began to eat. This behavior surprised the Chapmans, who thought that the chicken leg would have been more appealing to the bird. Under different circumstances chicken meat would, indeed, have been the more likely to be chosen, but inasmuch as he now showed that he was ravenously hungry, and probably because his leg was painful and he would have had trouble holding down the chicken leg with one foot while grasping the perch with the other, he chose the hamburger, evidently because he recognized that it would be the easiest to eat.

One week after he came into my care, I transferred Bubo to the barn, where there were many low-level perches as well as large beams that ran from one end of the building to the other. The barn, which was thirty feet wide by fifty feet long, was divided in two sections. One part, in which I put the owl, ran from floor to roof, the upper story having been used as a hayloft. The building had sheltered many animals, including a moose, a bear, a pair of otters and a variety of other mammals and birds. At one end I had earlier placed several perches, the lowest four feet from the floor, the highest eight feet, each with its own feeding platform.

As matters turned out, the owl remained in my care for the next three months, for the injury to the leg proved hard to heal. Although I spent a lot of time worrying about the bird's condition, I also derived interest and pleasure in the fact that Bubo, after some three weeks, accepted me to the point where I could walk right up to him and have him take food from my fingers.

When Bubo finally left me, I was to find out in due course that he remained in the general area of my property, which backed on to many thousands of acres of government land. I made the discovery one night when I was teaching a teenager, the son of a friend of mine, how to walk in the dark forest. I was trying to convince him that the use of a flashlight under such conditions was a hindrance rather than a help, for once human eyes become accustomed to the dark, they are able to guide their owner, albeit one must move far more slowly than during daylight. The young fellow had been quite nervous when we entered the forest, but after a while he began to relax—until Bubo greeted me with his usual unearthly scream as he landed on a branch above our heads!

On Sunday, May 5, 1968, I received a call from a woman whose fifteen-year-old son had taken a young horned owl from its nest, carried it home and put it into a wooden box in his bedroom. The boy's mother explained that she had not been at all happy with the introduction of a "dirty, vicious bird" into her home, but she put up with it for a week, at the end of which time she said that her son was "savagely bitten by the creature, so it had to go."

"I called the OSPCA in Newmarket, but they said they didn't take owls and they gave me your number. Will you take the bird?" she concluded.

I agreed to accept and care for the owl, of course, but because the boy's home was more than twenty miles away, I asked the mother to bring the bird *and* her son, for I wanted to get information from him and, also, I wanted to examine his injury while giving him a lecture.

When they arrived, I learned that the teenager and a friend had been walking along a trail in a forest near their homes when they saw an owl (it was obviously the male) fly to a tree with a mouse in its beak.

"The other owl stuck its head out of the hole and took the mouse and I guess gave it to the young, 'cause they sure made a big ruckus," the boy said.

On hearing the hissing noise of the owlets, the lad decided to climb the tree—the nest was evidently inside a hole that was located about eight feet from the ground. First he stood on the shoulders of his companion and thereafter shinnied up until he reached the nest just as the female burst out of it and flew away while uttering her alarm calls, a series of loud, prolonged *whaaa-wah-whaaa* sounds that are impossible to describe effectively in writing. The male, meanwhile, sitting in another tree, was evidently hooting repeatedly.

The boy thrust a hand into the nest, made contact with an owlet and pulled it out. Then, in order to have both hands free for the descent, he called to his friend and asked him to catch the bird. Fortunately, the friend was wearing leather gloves, otherwise the chick's sharply pointed talons, although small as yet, would have almost certainly scratched the boy's hands.

Moments later the nest raider slid down the tree, took his own gloves out of a pocket of his jacket and, putting them on, accepted the screeching owlet from his friend, who, I understood, was only too happy to relinquish the crying, angry bird.

By that time in the breeding season, the chick had lost most of its down and had begun to fledge, but it could not fly; yet it was obvious that it could hop while fluttering its partly feathered wings. As I was to find out later, it could also climb well, reminding me somewhat of the hoatzin chick that I had seen climbing along the branches of a tree before it plunged into the river.

As matters turned out, the boy's supposedly serious injuries were a few talon scratches, and his mother—I never did know the family's name—was only too happy to leave once I had settled the owlet in the basement. Before stepping out of the door, however, she paused to thank me for accepting the care of the bird; and she gave me a five-

dollar bill so that I could buy food for it. I almost rejected the money, but the woman meant well, so I accepted the donation. Before leaving, the boy shook my hand and vowed to telephone me at intervals to find out how "his" owl was doing, but I never heard from him again.

Settled temporarily in my makeshift clinic, the chick was left to its own devices while I prepared food, once again using chicken legs. I kept a supply of these frozen, for apart from carnivorous birds, I was feeding a number of other animals, including, at that time, a very energetic infant mink, a young skunk and two young raccoons. And all of them liked chicken!

Nevertheless, and although loath to do so, I started trapping and killing mice and voles for the owlet. When raising a young carnivorous bird in captivity, it is important to feed it the kinds of prey upon which it must survive in the wild. I did restrict the amount of food in accordance with the bird's appetite, for I learned early on that fledglings will overeat if they can manage to do so, probably because of the sibling rivalry that exists in the nest. At times a chick may overeat at the expense of a sibling, only to find at the next feeding time that it is too full to join the melee, and one or more chicks that were earlier deprived may well get the "lion's share." Thus, in a wild state, individual birds may gorge today, but fast tomorrow, as it were. In any event, within the nest, food consumption tends to even out, whereas a single chick force-fed by a doting human runs the risk of gorging itself to death.

Because of the sprouting wing feathers and the loss of down, I judged the owlet to be about four weeks old, a guess that one week later proved accurate, for on entering the clinic I found the bird sitting on the top of a six-foot ladder. As I was about to approach, the owlet flew to me and landed on my shoulder, where it began to clack its beak and flap its partly grown wings, begging for food, which, as it happened, I had brought with me: a dead vole.

On an impulse, I lifted the vole with my left hand, holding it by

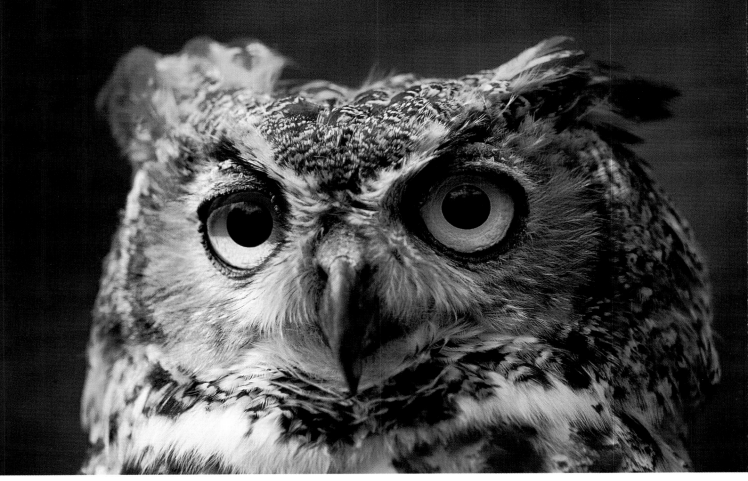

A powerful predator, the great horned owl hunts a wide variety of birds and small mammals in the early evening and at night.

the tail, and offered my right arm as a perch. Within about four seconds the owlet landed on my arm, reached forward and grabbed the vole with its beak. Immediately afterward it flew to the long perch, where it tore into the "prey."

Now I had a problem! Young great horned owls are fed assiduously by both parents in turn, which means that the owlets eat about every fifteen to twenty minutes between sundown and sunup and perhaps during early morning and late afternoon. I was *not* in a position to feed the bird every fifteen or twenty minutes. Debating the matter, I finally decided to overfeed the owlet. That is to say, instead of feeding it one mouse, or vole, every twenty minutes, I would put on the platform six dead animals at one time, then wait to see what transpired.

As matters turned out, my program worked. The owlet devoured the first offering, then "guarded" the others by mantling them when-

ever I entered the clinic. Over time, the owlet consumed between eight and eleven voles or mice during the course of twenty-four hours, doing most of its feeding between sunset and sunup, but on more than one occasion awakening in daylight to eat one or more mice.

I had not intended to give the bird a name, thinking that I would soon be able to release it, but after two months, I realized that the bird was seeing me as its parent and I felt that if I turned it out at that stage, far away from its original parents, the owlet might die. So, I chose a name, Virginia—for *virginianus*—for I felt relatively sure that the bird was a female.

Virginia stayed with me for a total of eight months, not because I decided to keep her for that length of time, but rather because she would not leave. All told, I took her outside at night fourteen times, on each occasion believing that she would settle in the forest. But she would always come back, usually just before daybreak, and sitting on a large tree that stood just outside my home, she would call endlessly until I was forced out of bed. Wearing a robe, I would go outside, raise one well-padded arm and whistle. She would glide in silently, land on my arm and begin to bob up and down, a little ceremony that lasted until she entered the clinic and flew onto the perch, whereupon she demanded food by clacking her beak and hissing. Then, receiving a mouse, she would pin it to the perch with her claws and mantle it until I left the room. By then I had made it a habit of waiting an hour before going downstairs to observe her. She was usually asleep, head turned under a wing, but it was obvious that she always enjoyed the mouse, despite the fact that she usually left about half of it, which told me that she was quite able to hunt on her own. Nevertheless, it was eight months before Virginia decided that her proper place was in the forest, although if I went into the woods at night, she always found me and usually landed on my shoulder. In time, she evidently found a mate and became independent of me.

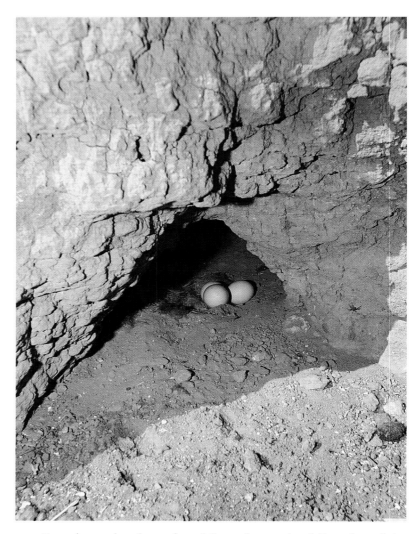

A great horned owl's nest in a cliff cavity. These owls also use the nests of other birds in tree branches or cavities.

Great horned owls are found from the north of Canada and the USA—in western and central Alaska, central Yukon Territory, southern Mackenzie and the Keewatin region of the Northwest Territories, northern Ontario, northern Manitoba, northern Quebec, Labrador and Newfoundland—and south in the Americas all the way to Tierra del Fuego. In Canada, the USA and Central America, no fewer than twelve subspecies are recognized by ornithologists.

The European counterpart of the great horned owl is the eagle owl, *Bubo bubo*. Most ornithologists believe that the two owls are so closely related that they represent a superspecies. Certainly, if the two

species were put side by side, the average birder would be hard put to note the difference. *Bubo bubo* is found throughout Europe, although it is not as plentiful as in the past, for it has been constantly hunted, its habitats have been destroyed and, of course, its prey has dwindled. However, it is still relatively common in Germany, Belgium, France and other regions of Eurasia.

The calls of the great horned owl are difficult to describe inasmuch as these birds appear to have a variety of vocalizations. As a rule, for instance, male calls last longer and are more complex than those of females; nevertheless, females at times utter calls that are similar to those of males.

MEASUREMENTS

	Female	Male
Wing:	16.2 in / 405 mm	14.4 in / 360 mm
Tail:	10.2 in / 255 mm	9.4 in / 234 mm
Length:	22 in / 56 cm	21 in / 53 cm
Weight:	55 oz / 1560 g	42 oz / 1200 g

Eggs

Description:	2.2 x 1.9 in / 56 x 47 mm. White, subelliptical to elliptical. Smooth and slightly glossy

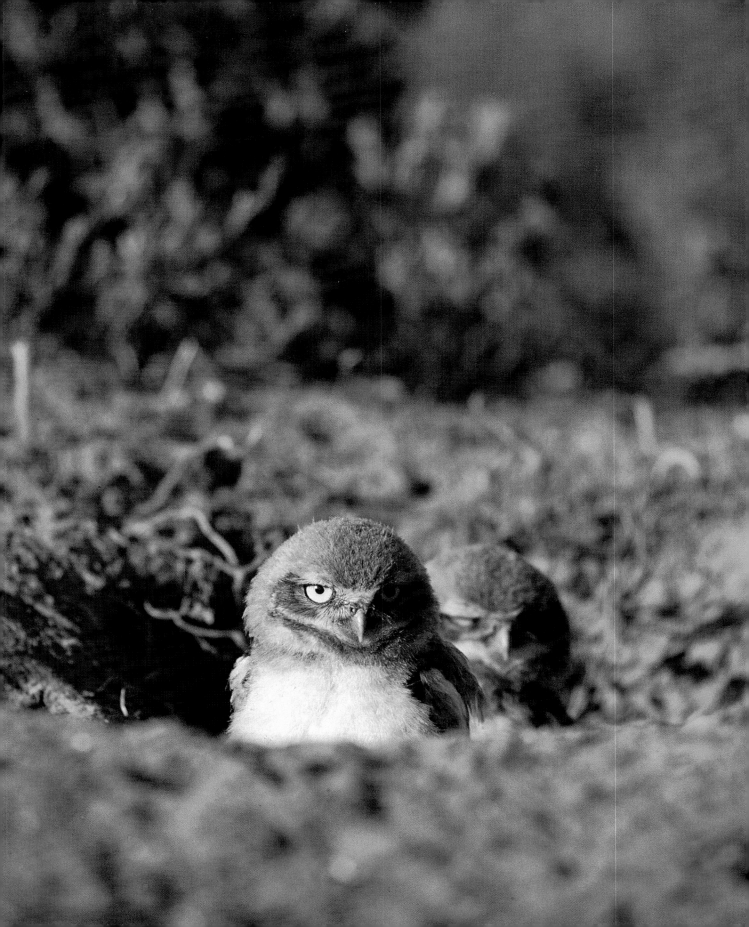

THE BURROWING OWL

Following my research in Venezuela and Amazonia, which ended in June 1960, I spent time in South America visiting some of the regions that Charles Darwin explored during his famous voyage of discovery. My own puny "expedition" I undertook more out of curiosity than anything else. It did not take me beyond the Argentine pampas, which I entered after crossing an area of flatland that was the home of burrowing owls (*Athene cunicularia*). In this baked region there were numerous underground nests, some of which had evidently been dug by the owls.

Seeing more than a dozen long-legged and stiffly standing little owls, some atop their observation mounds, others beside the entrance to their burrows, and yet others strutting backward—retreating from me, although I was a good distance away—was a fascinating experience. Added to it was the presence of a large number of viscachas, relatively large plant-eaters related to chinchillas. They live in pampas regions in company with the owls and frequently allow the birds to take over their burrows.

Opposite: Two burrowing owls stand outside their burrow. When they are alarmed on the nest, these owls are said to make a warning call that sounds like a rattlesnake.

Among several books that I had brought with me on the journey was a tattered copy of Charles Darwin's *The Voyage of the "Beagle,"* a book that I had inherited from my father and which was so "used" that it was illegible in some sections. Nevertheless, inasmuch as I knew that I was going to be in the burrowing owl's domain, I had brought it with me when I left most of the remainder of my gear in a small *pension* in Buenos Aires.

Now, leafing through the book, I found the section in which Darwin described the burrowing owl and the "Bizcachas" (viscachas), noting that the owls inhabited "exclusively" the burrows of the furry mammals. Later, when he was in another Argentinian region, Darwin noted that in the absence of viscachas the owls dug their own burrows. In fact, as is common wherever the burrowing owls exist, the birds will quickly adopt the vacated burrows of ground squirrels, which are found in grassland regions in the Americas as well as in many open regions of Eurasia. These habitats are generally level, open and covered by vegetation that is usually grazed by cattle—which replaced the near-extinct European bison.

It has been said that the nesting areas of burrowing owls "always have available perching sites," and this may be true in today's regions where cattle fences abound. But in other regions, and, indeed, in the years before the advent of fences, the owls most frequently sat on top of the mounds of earth excavated from the burrows. In flatland regions, this gave the birds sufficient elevation from which to see the approach of predators such as badgers and coyotes. In other regions of the burrowing owl's range, the birds nest in rocky outcrops that have fissures, or narrow openings, through which the owls can travel, but not their predators.

The majority of owl burrows that have been excavated by curious ornithologists slope downward gradually for a more or less straight distance of about 3 to 5 feet (approximately 1 to 1.5 meters), bend to the left, or to the right, for a short distance, then end at the nest cham-

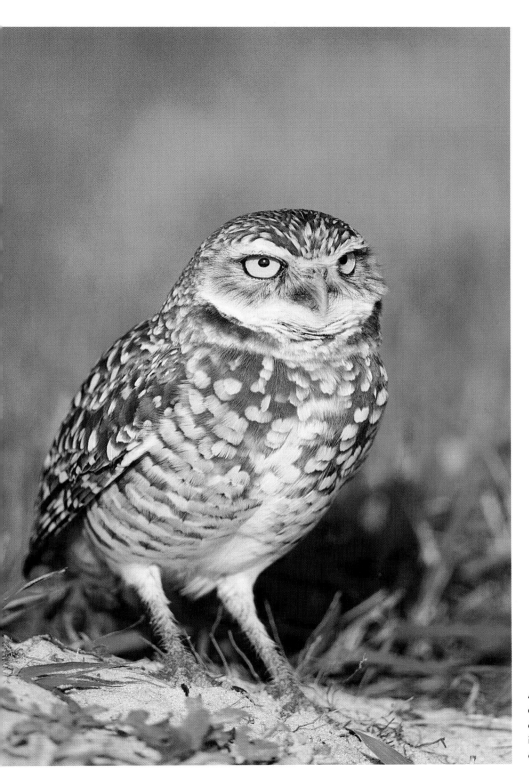

Although predominantly a west-
ern bird, the burrowing owl is
also found in Florida, where it
inhabits golf courses, airports
and other treeless areas.

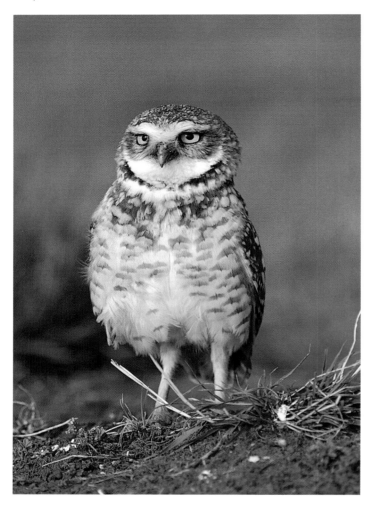

When they are disturbed, burrowing owls engage in vigorous head-bobbing motions.

ber, which must remain in darkness during egg-laying and the subsequent feeding of the young chicks.

It appears that pair bonding among burrowing owls is not permanent. Although little research has been done on this topic, it seems that it is the males that select nesting burrows. Indeed, males will always seek to choose the same burrows occupied by them during the previous breeding season.

On arrival, a male owl begins to prepare the nest by first scratching up the old debris and in some manner (which is not known at this time) getting rid of it. Then he begins to collect a variety of items for the nest, the first being dried mammalian feces with which to line it. Next he carries in small bones, straw and other oddments, but whether these are for the purpose of making a good home for the mother and her future young, or whether the male decorates in order to please his mate, is something of a mystery. At this time, male owls seem to get into the "swing of things" and begin to perform courtship flights outside their burrows, singing nonstop almost through the entire night.

The size of the home ranges of the burrowing owl depends on the conditions of the terrain and varies in the Americas from 0.01 to 1.93 square miles (0.25 to 5 square kilometers). It is evident that the

birds are not greatly territorial, confining themselves to the defense of a relatively small area immediately surrounding the burrow.

The plumage of the two sexes is similar, the females being more barred on the underparts, while the males during summer are somewhat lighter and more gray than brown. Generally, however, both sexes are brown above and are marked heavily by yellowish-brown or whitish-buff spots. The beaks can be either grayish or yellowish, the irises of the eyes are yellow, the toes and the "ankles" are light gray.

Inasmuch as burrowing owl nests are underground and only reached by a human by means of excavation, any attempt to count the eggs of a clutch will cause the sitting owl to fly out at the first sign of shoveling, or as soon as earth begins to fall inside the tunnel. Such disruption of the nest in order to count eggs is inhumane, and, in the end, it may well lead to broken eggs, dead owlets or both. In any event, and so far as it is possible to determine with any certainty, a breeding bird lays five or six eggs, or as many as eleven.

The female broods alone. She is fed regularly by the male, who at that season is likely to hunt more food than can be eaten by either bird, in which case he caches part of the bounty. Incubation usually begins with the laying of the first egg and, assuming that the female lays an egg every day, incubation will last for twenty-eight or thirty-two days. On hatching the young are *altricial* (immature and helpless), and they are lightly covered by sparse, gray-white down, which is replaced about two weeks later by the first feathers.

Burrowing owls are loquacious and have at least eighteen different calls. Even the owlets are known to have three calls. Nevertheless, perhaps the most important call of the male owl consists of a series of *coo-coooos*, which lasts about half a second. The female's most common call sounds somewhat like a flat, sharp *whack*. Males as well as females also utter a warbling call during the mating season.

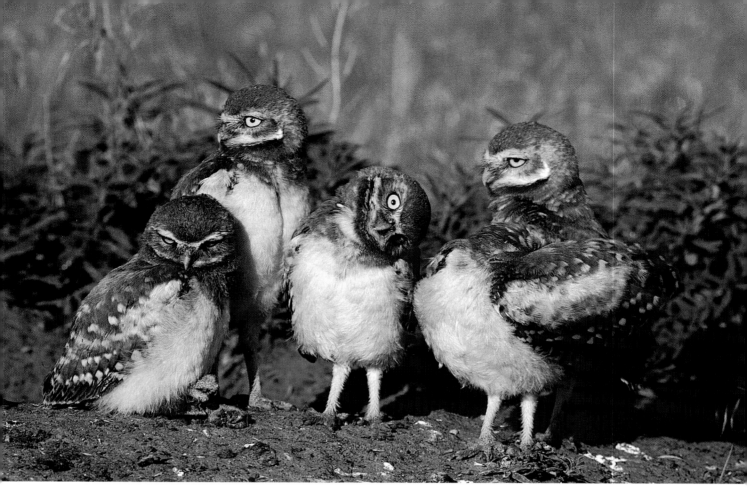

Burrowing owlets gather at the entrance to their burrow.

In summer burrowing owls in the Americas feed extensively on insects, including locusts, dragonflies, grasshoppers, crickets, cicadas, scarab beetles and moths—the majority of flying insects being caught on the wing. Additionally, throughout the seasons the owls feed on small mammals, including ground squirrels, chipmunks, the young of prairie dogs, shrews, cottontail rabbits, rats, mice, bats and some birds.

Burrowing owls in the northern regions of their North American breeding territories, where cold weather is severe, fly southward for the winter, some North American populations flying as far south as Guatemala and El Salvador. These owls are also found year-round throughout Central and South America, with the exception of a heavily forested region in north-central South America.

MEASUREMENTS

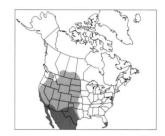

	Female	Male
Wing:	7.2 in / 180 mm	7.0 in / 176 mm
Tail:	3.4 in / 85 mm	3.2 in / 79 mm
Length:	9.8 in / 25 cm	9.1 in / 23 cm
Weight:	7.9 oz / 225 g	6.6 oz / 186 g

Eggs

Description:	1.2 x 1.0 in / 31 x 26 mm. White, smooth and glossy. Incubation by female.

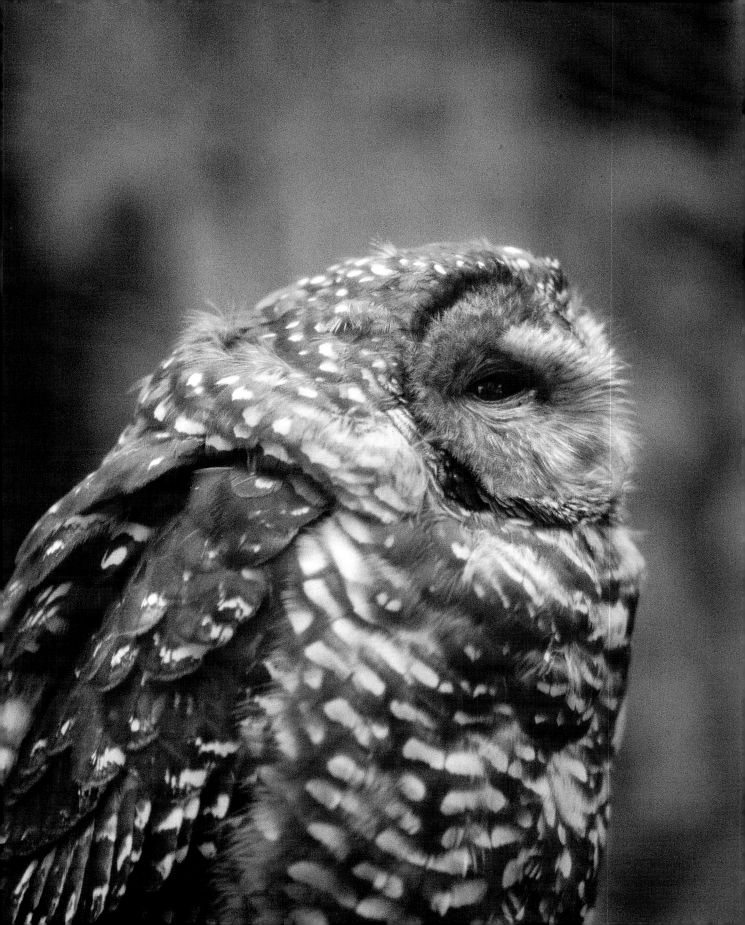

THE SPOTTED OWL

T here are four races of spotted owls: *Strix occidentalis*, resident in mountains along humid coastal forests; *Strix occidentalis caurina*, the second race, is also distributed over a narrow band that in the north begins in the extreme southwest corner of British Columbia, almost at the border of the state of Washington, and from that point continues south in a narrow band along the coastal ranges of the United States, down to central California. The third race, *Strix occidentalis occidentalis*, continues along the coastal ranges almost to the western border of Mexico, while the fourth race, *Strix occidentalis lucida*, begins inland in northern Arizona along the interior slopes of the Sierra Nevada and continues through southeastern Utah and southwestern Colorado, then south through western Texas to the Mexican Plateau at Michoacán and Guanajuato.

Because the logging of mature coniferous forests has increased drastically during the past twenty years in the historic range of the spotted owls, three races may well be in danger of extinction within the foreseeable future, despite the fact that officials in Canada and

Opposite: The spotted owl is an endangered species in both the United States and Canada.

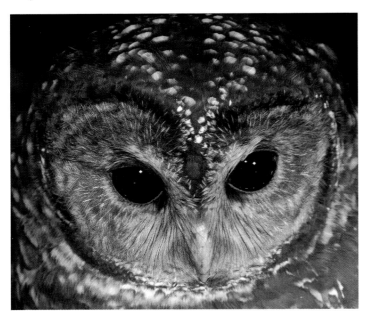

The call of the spotted owl consists of three or four doglike barks and cries.

the United States are seeking to set aside regions where the birds and their food base can continue to survive. Such regions must offer the owls old-growth forests, or, at least, a mix of mature and old-growth regions. Significantly, forests that have been entirely cleared or have been burned off in recent times have been entirely abandoned by these owls.

There is no doubt that spotted owls have until modern times survived in western forests where many trees were at least 250 years old, locations where deadfall timbers slowly decomposed on the forest floor and themselves offered nesting and food sources for many prey species, and where giant evergreens provided shelter for the owls as well as for the species of animals on which the birds survived. At this time, although the prey populations are not as plentiful as in the past, there are still sufficient numbers of flying squirrels, wood rats, voles, white-footed mice, snakes and insects to satisfy the needs of the owls in parts of the forested areas, but as the habitats decrease through logging, the birds and their prey are decreasing correspondingly.

Spotted owls tend to be sedentary, although as logging continues, they must move to different locations, some of which may be already occupied by other owls, or by their young or other juveniles. Thus, competition for prey and for suitable nesting areas can lead to dispersion to unsuitable locations or to fighting for space.

Where available, cavities in old-growth conifer trees are preferred nesting sites, second only to platform nests, also in coniferous trees, which are constructed with mosses, lichens and dead branches. In

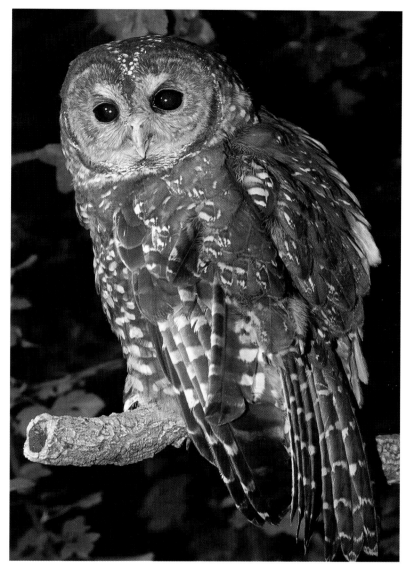

Adult and young spotted owls are sometimes hunted by great horned owls. The young owls may also be preyed upon by red-tailed hawks.

many instances, platform nests are the abandoned nests of hawks, squirrels or wood rats, and some nests are made within the shelter of dense clusters of mistletoes. Nest heights vary from 13 to 66 yards (12 to 60 meters).

Breeding season varies from early March to late May, depending on climate. Two eggs are usual, although three and, unusually, four have been noted. Incubation, which begins almost immediately after the first egg is laid, is by the female, who is fed by the male. It lasts

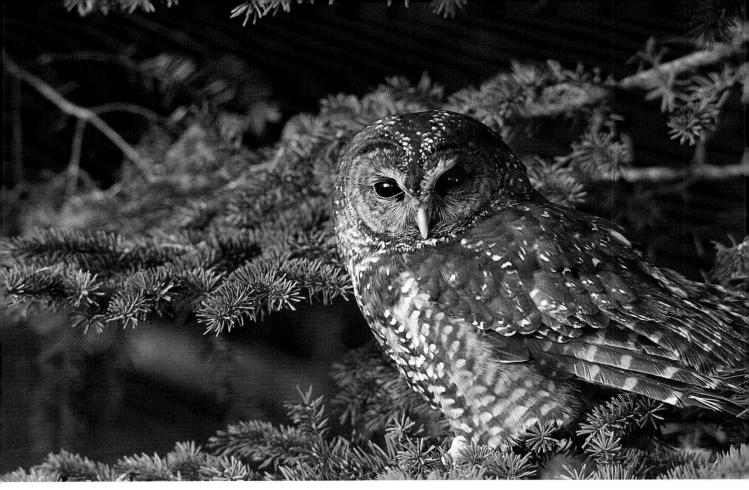

Spotted owls are forest birds; they usually avoid open areas.

between twenty-six and thirty days, although the time factor may vary in accordance with climatic conditions and altitude.

While the female is sitting on the eggs, and after the owlets are born, the female broods almost constantly while being fed by her partner, but after the young are about eight or nine days old, she leaves the nest to forage for short periods, joining the male in this task. Then, when the young are about twenty days old, she hunts for longer and longer periods.

The owlets leave the nest when they are about five weeks old. At that time they are almost fully fledged, although the flight feathers are not yet completely developed; on occasion, this causes the owlets to flutter down to the ground. Remarkably, however, and kindling memory of the hoatzin chick, the young owls are able to climb up into trees by using their beaks and their talons.

As a result of the spotted owl's dependence on old-growth

forests, this bird's status is causing great concern, as logging companies cut down more and more trees in the bird's habitat. It is almost certain that once the ancient conifers are slashed down, the owl will become but a memory.

MEASUREMENTS

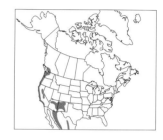

	Female	Male
Wing:	13.2 in / 330 mm	13.0 in / 324 mm
Tail:	9.0 in / 224 mm	8.7 in / 216 mm
Length:	17.5 in / 44.5 cm	16.5 in / 42 cm
Weight:	22.6 oz / 640 g	20.6 oz / 585 g

Eggs

Description:	2.2 x 1.7 in / 54 x 43 mm. White, elliptical to short subelliptical, smooth with slight grainy texture. Usually 2, at times 3, rarely 4. Incubation by female alone.

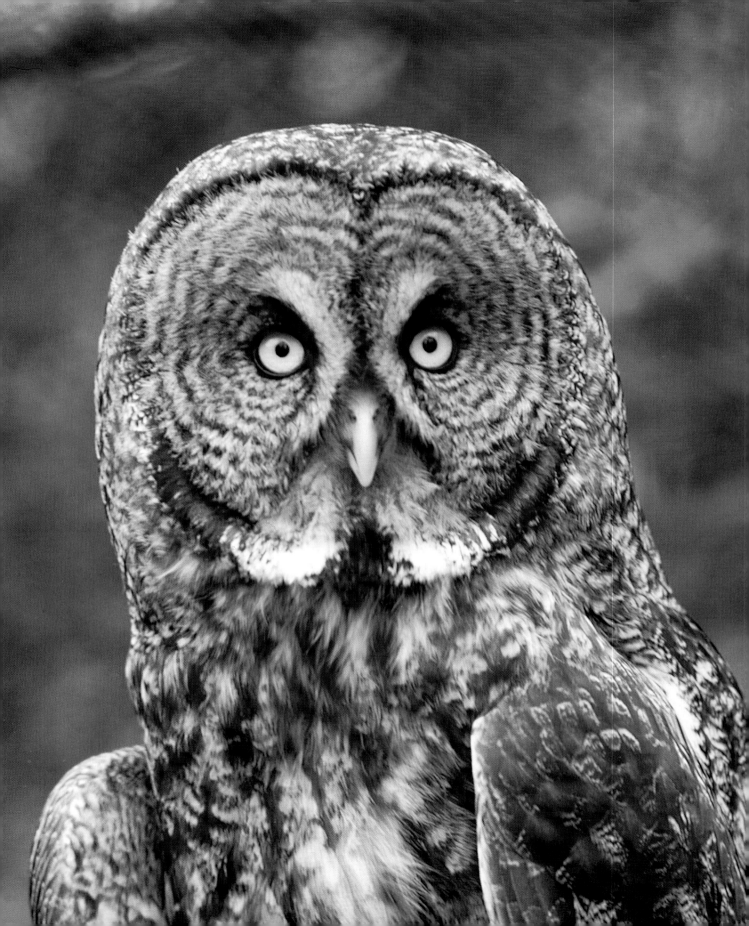

THE GREAT GRAY OWL

I have had only one close contact with the great gray owl (*Strix nebulosa*), but it lasted for an entire breeding season. Our first encounter was unforgettable, in the first place because the bird, a male, flew at me when my back was turned to him and at a time when I was not aware that there were *any* owls of any species in the area; in the second place, because he came sweeping down on silent wings low over my head and knocked off my hat, then skimmed upward and away while uttering a series of cries that to my ears sounded like *oooh uhuh* and were repeated excitedly as he disappeared within the forest.

Not long before the owl's "attack" I had pitched camp in a long, curving valley of British Columbia's northwestern mountain country. I was there to research the behavior and relationship of wolves and ravens in the heavily timbered region that lies east of the Bell Irving River and west of the Nass River. The area is dominated by the Coast Mountains and is forested by white spruces on the lower slopes and by tall, heavily branched alpine firs at higher elevations. In the

Opposite: **The great gray owl is North America's largest owl.**

valleys and lower elevations grow aspens, black cottonwoods, white birch and thick clusters of dwarf juniper.

Being far from civilization, the montane—lowland mix offers ideal habitat for the big, ebony ravens that earn much of their living by following the wolf packs and sharing in the lupine kills, often guiding a pack to an injured or aged moose or mule deer.

Up to the moment that the owl sought to chase me out of his domain, I had been sitting on a boulder a few yards from my tent making some preliminary notes, but the abrupt removal of my hat caused me to drop pen and notebook and, of course, to look up, just in time to see the offending bird before he disappeared among the aspens that grew in profusion within about twenty-two yards of my camp. At first, because I had only seen the rear of the bird and the large span of his wings, I was not sure whether my visitor had been a great horned owl or a great gray owl, but on reflection I realized that the obviously angry call that he made as he dived at my head was not the aggressive call of the great horned owl, to which I had been treated many times.

The date was May 27. I had canoed into the region during mid-morning of the 24th, set up my camp by early afternoon and had rested for a time before preparing myself to seek signs of the wolves and the ravens.

On the morning of my third day, an hour before full sunup, I sat on a log near my tent, drinking coffee while frying the last of my bacon and toasting two thick slices of sourdough bread, when I heard the raucous calls of a raven. The bird was some distance away, but it seemed excited about something. Listening to the calls, I wondered if I would be lucky enough to find a raven's nest, for the breeding season in the north usually begins about mid-April and the chicks are born between twenty and twenty-two days later. From past experience I knew that my chances of finding the nest, which by now would contain three or four partly fledged chicks, were slim; but I hoped that my

breakfast fire and the aroma of coffee would attract one or the other of the birds, for ravens are nothing if not curious and are always on the lookout for food.

As matters turned out, my hope was not in vain! I had only taken two swallows of coffee when a raven arrived, settled himself on a branch in an aspen, fluffed his feathers and cawed at me, almost as though he felt that I was intruding, which, of course, I was. The size and behavior of the bird led me to think that he was the male of a pair.

I tossed the raven a fist-sized piece of sourdough bread. It had hardly left my hand when he cawed and immediately launched himself off his perch and a split second later grabbed the food in mid-air, turned and flew away—only to return four minutes later to demand more.

I was about to break off another hunk of bread when a booming *whoo-oo-oo-oo* cry startled me and caused the raven to fly away at speed. He disappeared among the trees at about the same time that the great gray owl swooped low over my head, although it did not target my hat on that occasion. Instead, it flew into a nearby aspen and stared at me in silence for several moments, then, uttering the booming call again, it flew back the way it had come.

An hour or so after dark that night, while I was in my tent and preparing to crawl into my sleeping bag, the booming started again, but on this occasion from two different directions. One series of calls was not as deep as the other and was not as close, causing me to believe that the female owl had joined her partner's concert.

Six days after the great gray had knocked the hat off my head, he seemed to realize that my presence posed no threat to him, to his partner or to his young. He would visit for a short time during most nights, so I began to hope that if I followed him I might find the nest and the owlets. I tried on several occasions, but despite the fact that he continued to hoot from a distance, I was unable to discover

the nest's whereabouts; nor did I see the young owls throughout the time that I was in the area, even though before I left, the owlets would have been able to fly.

I would really have liked to have seen the female, but although she called now and then near my camp, I didn't so much as catch a glimpse of her. The male, however, continued to perch on nearby trees at night, from which he would serenade me with a series of deep calls that occasionally elicited a few curt responses from his mate.

Great gray owls inhabit North America from the northern regions of the Great Lakes in Ontario and northern Minnesota, north along the coasts of James Bay and Hudson Bay, west through most of Manitoba, in the central-northern regions of Saskatchewan, through most of Alberta, in the eastern third of the Yukon Territory up to southeastern Alaska and south through most of British Columbia, then in the states of western Oregon, northern Idaho, central Washington, Oregon east of the Cascade Range, south to California on both sides of the Sierra Nevada and extreme eastern Nevada. Great gray owls are also widely distributed in Eurasia, especially in northern regions.

The types of habitats favored by the grays are many and varied, ranging from regions heavily clothed by subalpine conifers, montane and boreal coniferous forests to a wide variety of other regions and trees, including such deciduous trees as aspens, balsam poplar and mountain ash, to name but some. Gray owls particularly favor habitats that contain both forested and open or semiopen locations, areas that are home to a variety of prey species such as mice, voles, young hares, squirrels, moles, shrews, gophers and others, including birds.

It is interesting to note that despite being the largest of all the owls, great grays clearly prefer to feed themselves and their young on small animals and, at times in winter, they often locate by sound a

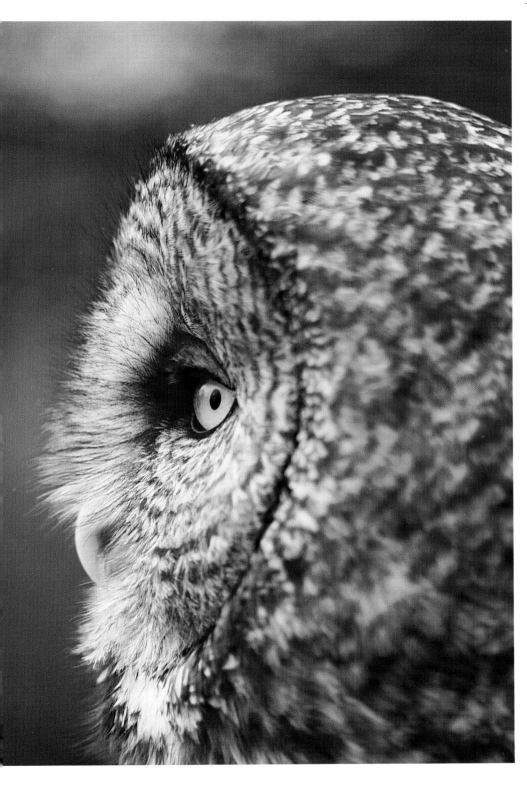

Although mainly nocturnal hunters, great gray owls may also hunt at dawn and dusk and on overcast days.

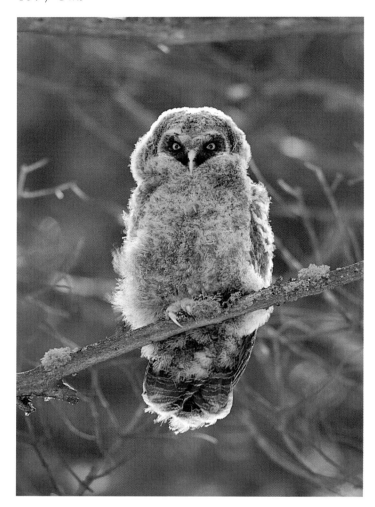

A great gray owlet photographed near the nest. These birds don't stray far from home at this age.

mouse or vole moving under the snow. When that happens, the owl may reach down with its claws and grasp the prey, but at times the bird actually dives headfirst into the snow while moving forward its legs, talons spread, to grasp the prey.

Great grays have exceptionally keen hearing, but they also have very keen eyesight. In fact, ornithologist R. W. Nero observed a great gray owl fly some 219 yards (200 meters) after it had detected a vole moving on top of the snow.

It has been noted by a number of observers that great grays and other owls often search for prey from relatively low perches, perhaps as low as 9 to 11 yards (8 to 10 meters), and it has been supposed that such heights offer clearer visibility and, therefore, better opportunities to find and kill prey. Such a supposition is undoubtedly accurate, but from personal observation of a number of perching owls of different species, I have noted that the lower forks of trees are less encumbered by other branches and so offer a clearer view of events upon the ground.

At times, great gray owls migrate in large numbers from their usual habitats to more southerly areas. For example, the mass migration in the winter of 1983–84 saw an estimated four hundred owls arrive in southern Ontario. A number of opinions have been offered to explain the reason for these migrations, such as that suggested by

Nero, who believed that the winter migrations were triggered by years of breeding successes as well as scarcity of prey species. Both are valid opinions that support the natural laws of supply and demand which affect all wild animals and occur, according to species, at irregular intervals.

The snowshoe hare, for example, goes from feast to famine every seven to nine years on average. When the hares increase dramatically in a particular region, food shortage and predation bring about major population crashes, which, of course, affect the animals that feed on the hares. Thus, it would seem highly likely that large owls, such as the great gray and the great horned, are periodically affected by such population ups and downs.

In his book, *Owls of Europe,* biologist H. Mikola notes that in the western Palearctic—the geographic division comprising Europe, Africa north of the Tropic of Cancer, the northern part of the Arabian Peninsula and Asia north of the Himalayas—the great gray owl is largely found in dense and mature lowlands and, at times, in coniferous forests mostly dominated by spruces and pines or firs with occasional patches of white birch. But hunting, in most cases, is not done within the forested land. Instead, it is done where large populations of small rodents are available—in the nearby, more open habitats that include cleared forests and marshes. Thus the owls appear to have the best of both worlds, having areas that supply abundant food and dense forests that offer shelter and ideal nesting sites.

Great gray owls do not mate permanently, and females do not have strong nesting site bonds, although they may brood in the same nest for several seasons. Sooner or later, however, a female will leave the old nest and will steal a bird's nest and make it over for her needs, or find an adequate tree cavity, or even construct her own nest.

When courting, which usually starts in mid-January and continues until mid-April, the female great gray owl utters quiet hoots and

starts to "dance," moving her weight from leg to leg as soon as she sees the male approaching with a prey animal as an offering. Next, the male alights on the perch, leans toward the female, closes his eyes and offers the prey. The female, also closing her eyes, takes the offering while uttering a relatively high mewling call. In this way, the pair-bond is formed. Thereafter, until the first egg is laid, the pair spend time preening and feeding each other.

Breeding season begins in late March in more southerly regions and ends in mid-May in northerly areas. The eggs are laid at intervals of two to three days. The female incubates the eggs and is fed by the male, although she leaves the nest for short intervals to hunt on her own.

At hatching the owlets weigh about 1.25 ounces (35 grams), but between five and six days after hatching they will have almost attained their hatch weight. The young usually leave the nest about thirty days after hatching, at which time they will have attained a weight of about 15 to 20 ounces (425 to 570 grams). At that stage, the chicks are nimble, using claws and wings to scramble about agilely in their nesting tree. They remain in the home area for several months, cared for by the female.

When newly hatched, the owlets enter their world dressed in a grayish tone on the back, and white on the underparts. The legs are a light yellow tinged with gray. It has been estimated that full fledging occurs when the owlets are about fifty to fifty-five days old, but they remain in the nesting region for a number of months before flying away on their own.

MEASUREMENTS

	Female	Male
Wing:	18.4 in/460 mm	17.7 in/442 mm
Tail:	14.0 in/348 mm	13.0 in/325 mm
Length:	27.2 in/69 cm	26.4 in/67 cm
Weight:	50.9 oz/1445 g	36.2 oz/1026 g

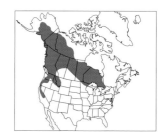

Eggs

Description:	2.2 x 1.7 in/54 x 43 mm. Subelliptical, but somewhat less rounded than the eggs of most owls. Three to 5, at times fewer, or as many as 9 (rarely).

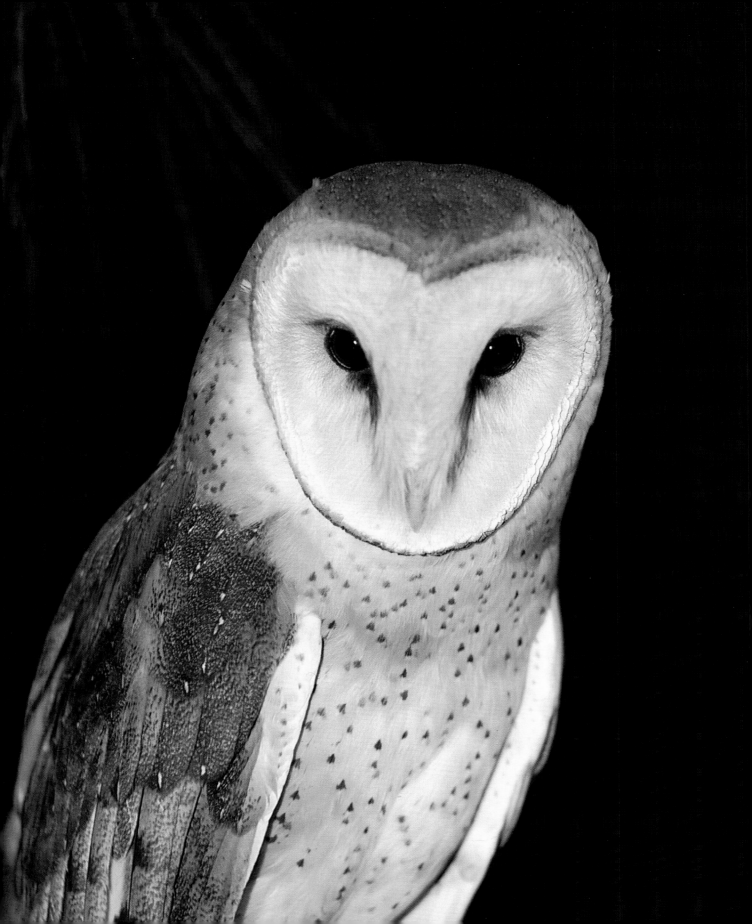

THE COMMON
BARN OWL

I f there lives in the world an owl that has more names than the barn owl (*Tyto alba*), I do not know of it. Counting its North American English and Latin names—but discounting the many different colloquial Spanish names bestowed upon the bird in Central and South America, the Bahamas and Cuba—this unusual owl is known by eighteen appellations.

The Ancient Britons of England may well have been the first to name the owl, calling it (in Celtic) *Dillyan wen*. The other names followed: yellow owl, screech owl (no relationship to the screech owls named today), gilly howlet, howlet, madge owl, church owl, hissing owl, common barn owl, *Strix flamea*, and, finally, today's Latin name, *Tyto alba*, plus the names of the recognized subspecies: *Tyto alba pratincola*, *Tyto alba lucayana*, *Tyto alba furcata*, *Tyto alba niveicauda*, *Tyto alba glaucops*, *Tyto alba guatemalae* and *Tyto alba bondi*.

Added to the above, the barn owl has gathered a variety of other names in other languages inasmuch as it is the most widely traveled owl of all, being at home in Canada, the United States,

Opposite: The facial disc of this common barn owl serves to reflect sound to its ears.

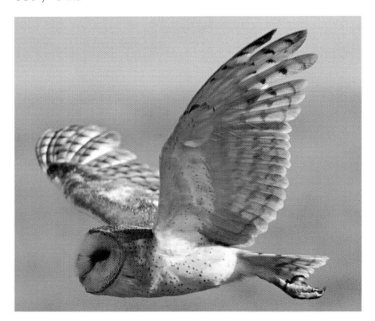

Unlike hawks, owls in flight appear headless.

Mexico, Central America, Cuba, the Bahamas, Eurasia, Asia, North Africa, Central and South Africa, Australia and New Guinea.

Who, I wonder, first named this bird *common*? It seems to me that *widespread* would much better describe this international night-stalker, which is literally one of a kind in a biological sense, although there is some learned argument that must yet decide whether the Old World bay owl (*Phodilus*) should or should not be included in the *Tyto* family. Be that as it may, there is no doubt that the barn owl is quite different from the members of the *Strigidae* family, to which all other owls belong.

Male and female barn owls are difficult to tell apart unless the birds are close up, when it can then be noted that the larger of the two is the female and she is somewhat darker in color than the male, particularly so on the chest and stomach area. Generally, the upper parts are of a buffy color, but the upper back and the top of the head is streaked by grayish black, giving a frosty tone, while the underparts may vary from buffy to a mild orangy shade that is stippled by dark dots or small, black bars. The wing feathers have an orange cast and are decorated by small, black patches running in rows, and the upper feathers are graced by lines of white spots, or grayish tones, these colors also running over the top of the head and contrasting with white feathers under the chin. The legs, to the ankles, are furnished with short, somewhat bristly, stiff feathers, while the feet are yellowish and provided with four black, curved and very sharp claws.

The facial disk, which is shaped somewhat like a heart, is white,

rimmed by a brownish orange "collar" that surrounds the disk and ends under the yellow beak.

Within each side of the disk, there is a brownish "slash," the upper part of which surrounds each slanting, dark eye, which, for an owl, is relatively small. Thus, if seen flying during daylight—which is probably unlikely—barn owls are quickly recognized by their white underparts and their heart-shaped disc. No other owl looks like *Tyto alba*.

It is believed that the barn owls developed in Britain in regions where the chalky cliffs and equally chalky, deep depressions in field areas and limestone coasts may have given rise to its colors, although many changes have occurred since then. Today, barn owls in Europe continue to choose open fields and shrubs or hedgerows for hunting purposes and, especially in Britain, tend to nest in church steeples, roof overhangs that offer space on the underside edges, old buildings and large hollow trees. All nesting sites are selected because of neighboring areas of grasslands or arable lands where prey species are in abundance. Lastly, and of major importance, the owls seek regions that have mild climates and shun areas of severe cold.

Barn owls are exceptionally vocal birds and produce a number of different sounds. At least seven calls emerge as sudden, high-pitched screams. Some of these are uttered in flight and, for obvious reasons, are probably the best known, for such shrieks can be intimidating when heard suddenly in the pitch of night while walking in an open area—to which I can testify! In addition, there are the hissing sounds, used for a variety of reasons, including alarm, distress and courting. Then, too, tongue clickings are at times sounded with defensive hissings. During courting, males often "clap" their wings, usually resorting to one loud clap and a second that is less sonorous, the performance repeated while the male hovers in front of his partner. It appears that none of these calls is the hoots of other owl species.

An analysis of the calls of *Tyto alba*, carried out in Germany in

1980 by ornithologists E. Bühler and W. Epple, indicated that these owls have a repertoire of eighteen different calls, which are estimated to fall into five different signal categories. The study showed that territorial calls consisted of various kinds of purring sounds and screeches; defensive calls included bill clacking and hissing vocalizations; feeding and begging calls included chittering cries and snorings; social interactions produced a variety of snorings and twitterings; and, lastly, the variety of calls uttered by half-grown nestlings could not be noted as serving specific functions.

Studies of the movements of young barn owls indicate that most of them move away progressively from the nest area and tend to settle in regions that are about 12.5 miles (20 kilometers) from their birthplaces. Some of the birds, however, may fly as far as 60 miles (97 kilometers) from their natal areas, while still others—as noted in a Dutch banding sample—traveled more than 180 miles (290 kilometers), flying in a southwesterly direction toward Spain, perhaps because of the milder climate.

In addition to the relatively regular travels of young owls, adult birds in some years undergo mass migrations for which there has been no clear explanation, although it is most likely that such sudden dispersals are due to a serious reduction of the prey species in those areas that have been more or less deserted.

The food of barn owls consists mostly of mammals that are small, easily killed and abundant during the nighttime, such as voles, moles, shrews, weasels, rabbits, bats, domestic mice and rats. Barn owls are such good hunters that several countries that were overrun by Old World rats and mice—especially Sri Lanka, New Guinea and Australia—have imported them. Because of the abundance of such prey, barn owls have been increasing their numbers in these countries while acting as flying pest control systems. Conversely, however, the numbers of barn owls in Canada and in the United States are decreasing, and although no specific reasons for the declines have so far been

acknowledged, a scarcity of small, feral mammals has almost certainly been caused by agricultural practices as well as, in some forested areas, by the competition with owls such as the great gray and the great horned.

Flying over relatively open land, barn owls usually begin to hunt at about dusk, gliding silently and usually flying against the wind so as to slow down their glides, a technique that allows them to see and hunt more effectively. The owls appear to fly over those routes that have tended to yield the best hunting in the past and, although these birds are usually peaceful when they encounter a member of their own kind, they do become jealous if intruded upon by another owl. Screeching loudly, the territory holder is usually able to chase away the trespasser without having to resort to fighting.

As a rule, barn owls feed at intervals, the first starting at dusk, the second at about midnight and the third, and last, at about dawn. After that, they sleep and, if not disturbed, will continue to do so until early dusk.

In England and other countries in about the same latitude, courting begins toward the end of February. Because of climate conditions, courting is later in North America and earlier in Mexico and Central and South America. One wooing display by the male, referred to as "the moth flight," begins when the male

Barn owl chicks. In addition to barns, the barn owl likes to nest and roost in church steeples, abandoned warehouses and hollow trees.

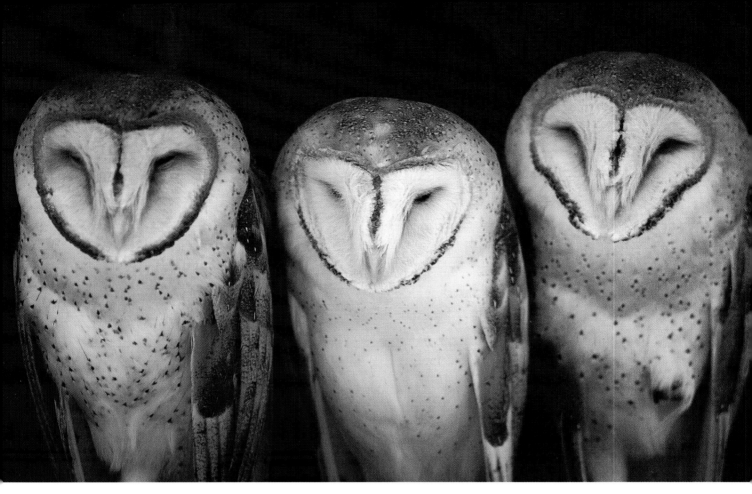

The common barn owl is on the endangered species list in seven Midwestern states.

flies to the sitting female and hovers in front of her, at her head level, while he flaps his wings rapidly and shows off his white underparts. Another male display is the "in-and-out flight." In this case he flies in and out of the nesting chamber, or nest site, in order to entice the female to enter her future home. While the male continues his antics, the female responds to his courting by uttering the snoring calls of juveniles, which stimulate the male and cause him to present food to her.

The breeding season, which may begin as early as February in warm climates or as late as May in others, is prolonged, and often a female will brood twice in a season. Starting with the first egg, laying continues at two- to three-day intervals. Incubation begins with the laying of the first egg so that as much as three weeks can separate the first born from the last born.

The young are altricial and downy and, unlike other owls, they

have two down coats. The first is white and short, sparse on the abdomen and covers the legs to the claws, but is absent on the back of the tarsus (the lower, long bone of the leg) as well as on the sides of the neck. The first down is replaced at ten to twelve days after birth by a thicker and longer down that is creamy buff. The eyes of the owlets have pale blue irises for the first three or four weeks, then take on the dark color of the species.

The young fledge when they are between fifty and sixty-three days old and soon thereafter start to take short flights away from the nest, probably at about the time that their mother is hatching a second brood, for courtship starts again when the first owlets are about seven weeks old. In fact, a female at times starts to lay a second clutch of eggs before the youngest chicks of the first brood have fledged.

MEASUREMENTS

	Female	Male
Wing:	14.3 in / 358 mm	13.8 in / 346 mm
Tail:	6.2 in / 156 mm	5.9 in / 147 mm
Length:	16.5 in / 42 cm	15.7 in / 40 cm
Weight:	20.5 oz / 580 g	18.4 oz / 522 g

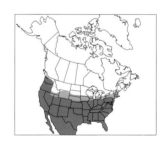

Eggs

Description:	1.7 x 1.3 in / 43 x 33 mm. Long and subelliptical. White, nonglossy, but smooth. Clutch variable: usually 4 to 7, occasionally 3 to 11. Female incubates alone. Young tended and fed by both adults.

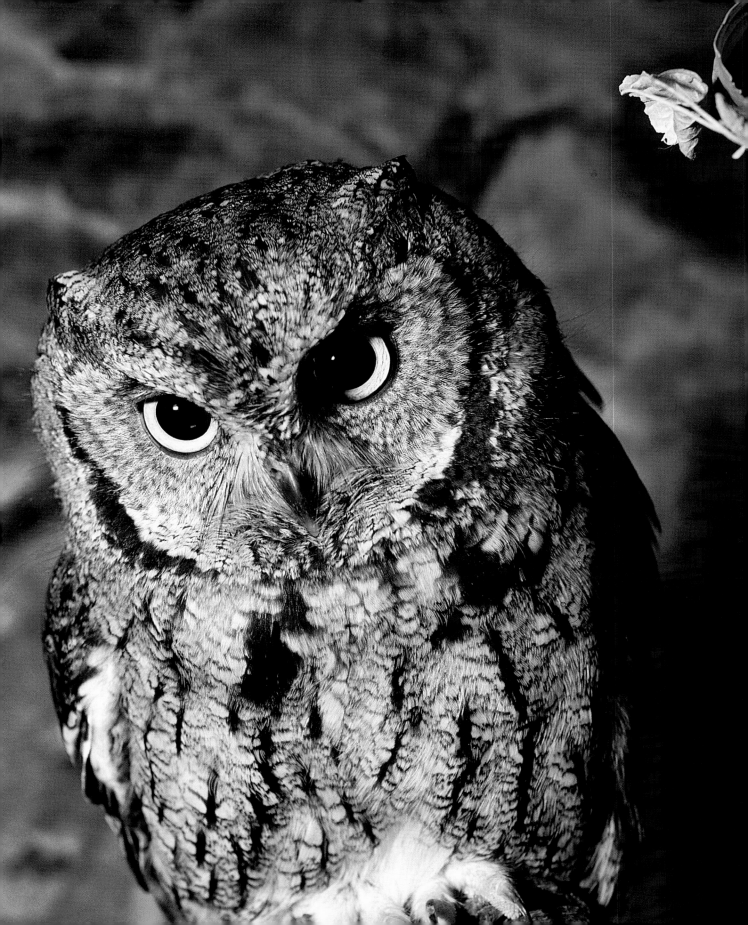

THE SCREECH OWLS

T here are three kinds of screech owls in North America, all evidently related, but yet separated by ornithologists into different breeds: eastern screech owl (*Otus asio*), western screech owl (*Otus kennicottii*), and whiskered screech owl (*Otus trichopsis*). Although differing somewhat in size, they all look alike, perhaps the exception being the so-called red phase of the eastern species, the color of which is more bright cinnamon than red. In addition to the three breeds, there are no fewer than seventeen subspecies recognized by ornithologists.

While respecting the biological approach taken by ornithologists—indeed, agreeing with them to some degree—I feel justified in lumping the three species into one treatment; otherwise, most readers may well skip the pages dealing with these interesting birds.

The eastern screech owl, the largest of the three, inhabits Canada, the United States and northeast Mexico from the shores of the Atlantic to roughly west-central Canada and the USA. In Canada, however, the population is scant, being found only in the southeast

Opposite: **The screech owls are the only small owl with ear tufts.**

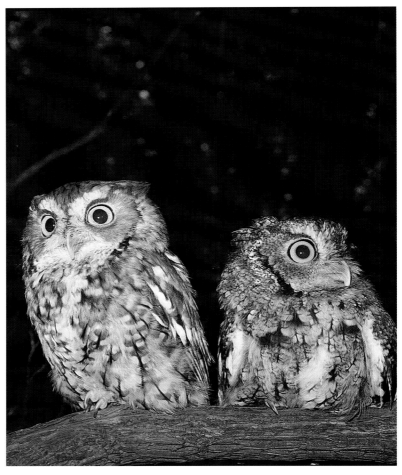

The two color phases of the eastern screech owl.

and as far west as the very southern areas of Manitoba and Saskatchewan with a small number inhabiting the Cypress Hills of southeast Alberta and southwest Saskatchewan.

In the USA and Mexico *Otus asio* has been split into five subspecies: *Otus asio* inhabits Minnesota, peninsular Michigan, southern Quebec, southern Maine south to Missouri, and northern parts of Mississippi, Alabama and Georgia. *Otus asio maxwelliae* is found in extreme southern Manitoba and Saskatchewan, eastern Montana and the Dakotas, south to eastern Wyoming, western Nebraska, western Kansas and northeastern Colorado. *Otus asio hasbroucki* ranges from central Kansas to Oklahoma and Texas. *Otus asio mccallii* lives in the region of the lower Rio Grande up to the summer borders of

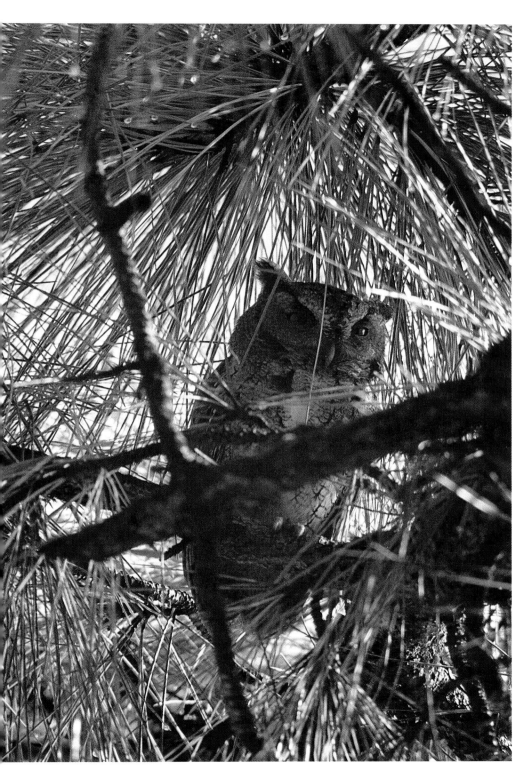

**Habitats of the eastern screech
owl include open woodland,
parks, orchards and swamps.**

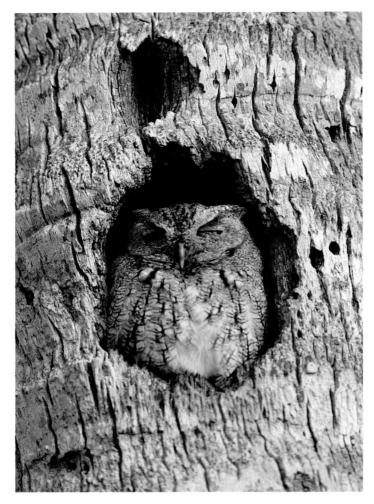

The eastern screech owl nests in holes in trees and in man-made nesting boxes.

Tamaulipas. *Otus asio floridanus* ranges through Florida, the Gulf of Mexico to Louisiana, and then north to Arkansas.

In the screech owls, the sexes are alike, but there are two color phases. In the gray phase, the owl is brownish gray to grayish brown above and finely mottled with black. The face is grayish white with dark brown above the eye, emphasizing the "ears" that start like a mustache on each side of the beak and then spread out like a V, meeting the narrow black band that rings the face. The beak is light grayish tending to dull green-blue. The eyes are lemon yellow with eyebrows that are jet black, while the toes and the upper parts of the claws are yellow-gray. The claws are dark. The main song of this owl is a whinny that begins in high pitch, drops slowly and in the end becomes a tremolo.

The eastern screech owl feeds largely on chipmunks, flying squirrels, moles, shrews, bats and mice. Many species of birds, including song birds, doves, ruffed grouse, woodcock and even birds of prey, such as the kestrels, are also part of its diet.

The western screech owl has been divided into no fewer than nine subspecies, which I do not propose to list in that, as I was once told by an eminent birder, "a subspecies is a bird with a different

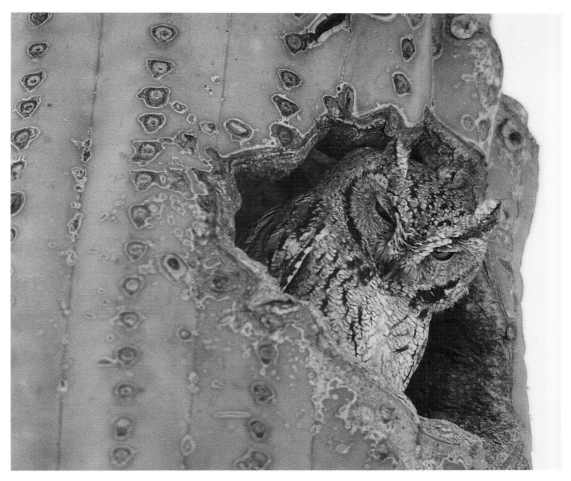

kind of appetite." In any event, *Otus kennicottii* is a western bird. It is found from northern British Columbia southward through Washington, Oregon, Idaho, western Montana, California, Nevada, Utah, Colorado, Arizona, New Mexico and Mexico from the Baja Peninsula to southern Mexico up to the states of Guerrero and Puebla.

As in the other screech owls, the sexes look alike and the bird's gray phase is similar to *Otus asio*, while the red phase, although known to occur, is rare. The bill is usually black and the eyes are yellow. This bird has a primary song that is referred to as a whinny, and a secondary call that consists of rapid trilling.

The western screech owl seems to prefer partially open country

A western screech owl peers out of its nest site in Arizona.

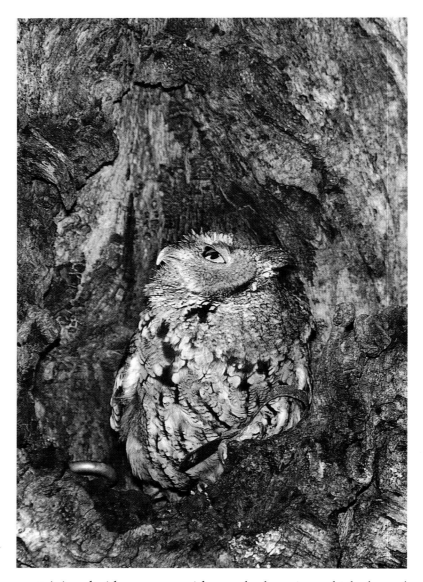

The western screech owl is most commonly seen in its gray phase. Its red phase is rare.

containing deciduous trees with gray bark against which the owl appears almost invisible.

These owls feed heavily on mice, but they also eat beetles, ants—especially the large carpenter variety—other insects, small grass snakes, worms, crayfish, as well as birds, including jays and flickers.

Nest sites vary according to habitat. Tree holes are used, especially those cavities excavated by woodpeckers and the holes in large cottonwood trees excavated by flickers. Areas where there are large

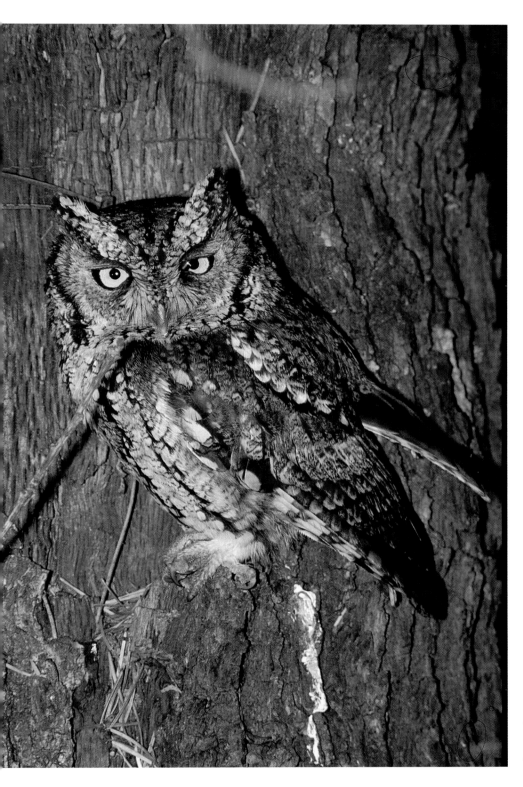

The whiskered screech owl
inhabits dense oak and oak-
conifer forests.

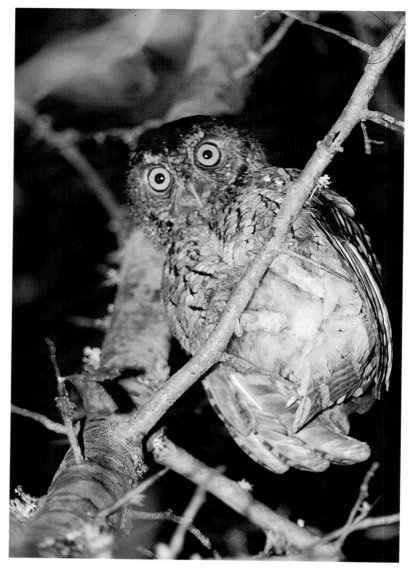

Whiskered screech owls can flatten their ear tufts, giving them a round-headed appearance.

willows in thick stands growing along stream banks are also favorite sites.

The whiskered screech owl, *Otus trichopsis*, is resident from southeastern Arizona to northeastern Sonora, Chihuahua, Durango, San Luis Potosí, Nuevo León and southward through the Mexican mountains to El Salvador, Honduras and northern Nicaragua. Three subspecies are recognized: *Otus trichopsis aspersus*, *Otus trichopsis trichopsis* and *Otus*

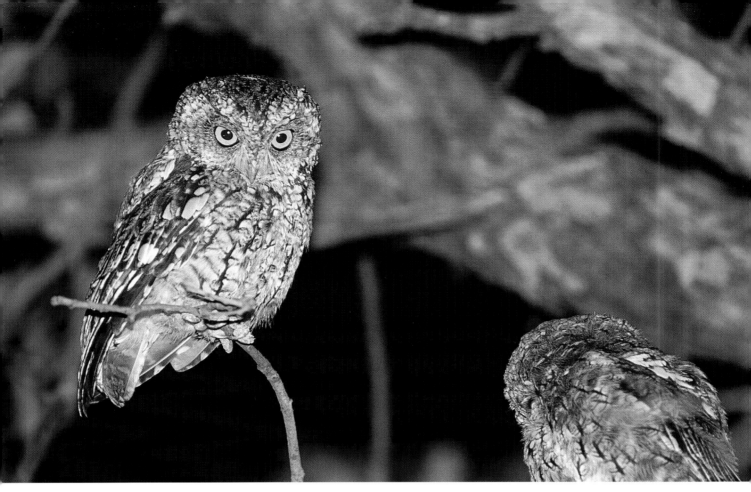

In areas where the whiskered screech owl and the western screech owl overlap in range, the whiskered is usually located at higher elevations.

trichopsis mesamericanus. Aspersus and *trichopsis* are found in southeastern Arizona, the southern Mexican Plateau from Michoacán to Vera Cruz, Chiapas and Oaxaca. *Mesamericanus* is found from central El Salvador to Nicaragua.

This is a sedentary species that may well occur too far south to be affected by the reductions in winter of the insects upon which it mostly feeds. Inasmuch as the whiskered screech owl has relatively weak feet, it is thought that it has become almost totally adapted to hunting invertebrates such as caterpillars, crickets, moths, mantids, grasshoppers, centipedes and the larvae of beetles. Centipedes are believed to be its most important winter food.

This owl is aptly named—its face sprouts a forest of long black whiskers. In the northern regions of its range, it is consistently light gray, but in southerly areas it is reddish brown.

M E A S U R E M E N T S

	Female	Male
Eastern screech		
Wing:	6.5 in / 162 mm	6.1 in / 152 mm
Tail:	3.0 in / 76 mm	2.9 in / 73 mm
Length:	16.5 in / 42 cm	15.7 in / 40 cm
Weight:	6.8 oz / 194 g	5.9 oz / 168 g
Western screech		
Wing:	7.4 in / 185 mm	6.9 in / 172 mm
Tail:	3.9 in / 98 mm	3.6 in / 89 mm
Length:	16.1 in / 41 cm	15.4 in / 39 cm
Weight:	6.7 oz / 186 g	5.4 oz / 152 g
Whiskered screech		
Wing:	6.0 in / 150 mm	5.8 in / 145 mm
Tail:	3.0 in / 76 mm	2.9 in / 72 mm
Length:	15.7 in / 40 cm	14.6 in / 37 cm
Weight:	3.3 oz / 93 g	3.0 oz / 85 g

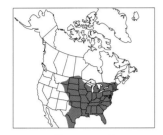

Eastern screech

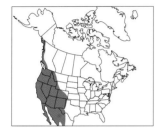

Western screech

Whiskered screech

Eggs

Eastern screech

Size:	1.4 x 1.2 in / 35 x 30 mm
Description:	Clutch sizes vary from 1 to 8 eggs laid between mid-March and mid-April, depending on environment. Brooded by female alone; incubation period about 26 days. Nestlings at first covered by white down. Second coat: olive on back and whitish with brownish bars.

Western screech

Size:	1.5 x 1.3 in / 38 x 33 mm
Description:	Other information not available.

Whiskered screech

Size:	1.3 x 1.5 in / 33 x 37 mm
Description:	Other information not available.

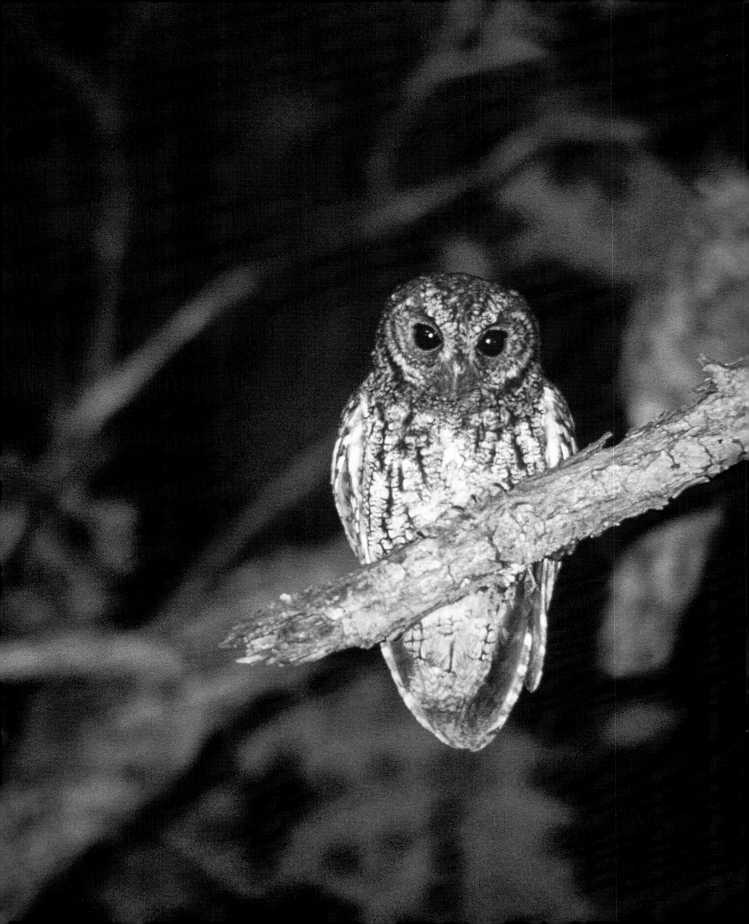

THE FLAMMULATED
OWL

Otus flammeolus breeds from southern and southeastern British Columbia, north-central Washington State, eastern Oregon, Idaho, western Montana, northern Colorado and southern California, southern Arizona, southern New Mexico, western Texas, Nuevo León, the state of Mexico and Veracruz. Wintering grounds are from central Mexico to the highlands of Guatemala and El Salvador.

These owls have two color phases. The gray phase is somewhat misnamed, in that the bird's feathers at this stage have a combination of brown and gray that is mixed with a darker hue. In the red phase the upper parts are a cinnamon brown. The face, with the exception of whitish eyebrows, is of a cinnamon hue. In both phases the beak is light gray, sometimes of a bluish tone, but may have a yellow tip. The toes are light brown. The eyes are deep brown.

The flammulated owl is small, females reaching about 7 inches (18 centimeters), males about 6.5 inches (16.5 centimeters). As though to go with the size of its body, its ears are also small and, seen

Opposite: In the United States, the flammulated owl is listed as vulnerable. In British Columbia, it is protected under the British Columbia Wildlife Act.

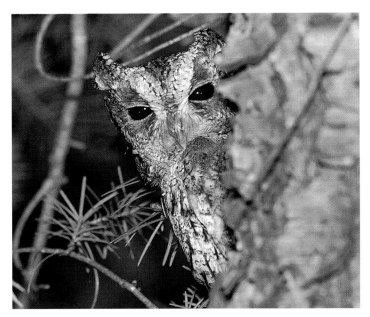

This shy owl is difficult to observe in the wild.

on a perch, it seems to want to hide its legs, which are densely feathered to the ends at the short, bare toes.

The male advertises himself with a low, quite mellow hoot, which at times sounds more like a boo. This call is uttered at regular intervals of about two seconds, while a mating call is a two-syllable hoot-hoot. Then, too, when near the nestling owls, the parent birds utter double-syllable calls that could be mistaken for the soft mewling of a kitten. As if to make up for the repertoires of their parents, the fledging owls utter a series of wheezing sounds every six or seven seconds, and for such small fledglings, the calls can reach far; they can be heard from a distance of 82 to 110 yards (75 to 100 meters).

Depending on their breeding range, flammulated owls use a variety of forested systems and trees such as ponderosa pine, Jeffrey pine, sugar pine, Douglas fir, white fir and black oak, but at breeding time they are more closely related to ponderosa and Jeffrey pine because of the warmer summers in the area of those trees.

The food of flammulated owls consists mostly of invertebrates such as beetles, crickets, centipedes, millipedes, grasshoppers, spiders, moths, scorpions and the like, although they also kill small birds.

In the breeding season, mid May to early June, the males sing throughout their home ranges. At times, the owl will call while standing against the trunk of a tall tree, or from within the crown branches. It appears that the male sings more frequently while his mate is incubating, but it also sings at night after the chicks have hatched.

Incubation starts after the second egg has been laid, hereafter the

female sits—with short intervals—for some twenty-two nights before the young hatch and while the male hunts for the sitting hen as well as for himself.

The young owlets are at first dressed in snowy down, with feet and beaks of a flesh color. The iris, like that of the adults, is dark brown, almost of a blackish tone. The upper parts of the chicks are barred with gray, the underparts are gray-white and barred with light gray or grayish white. Thirty-four to forty nights after fledging, the young owls are no longer fed by their parents and begin to disperse soon after, most by late August.

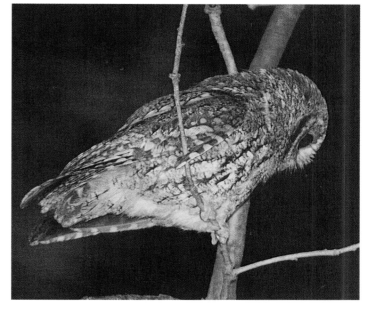

Threats to the flammulated owl include habitat destruction and modification and the use of pesticides to control spruce budworm.

MEASUREMENTS

	Female	Male
Wing:	5.7 in / 142 mm	5.5 in / 138 mm
Tail:	2.6 in / 66 mm	2.5 in / 62 mm
Length:	6.7 in / 17 cm	5.9 in / 15 cm
Weight:	2.0 oz / 58 g	1.9 oz / 54 g

Eggs

Description:	1.2 x 1.0 in / 29 x 26 mm. Elliptical to short subelliptical. White, slightly glossy, smooth. Usually 3 to 4 eggs. Incubation begins after the second egg is laid.

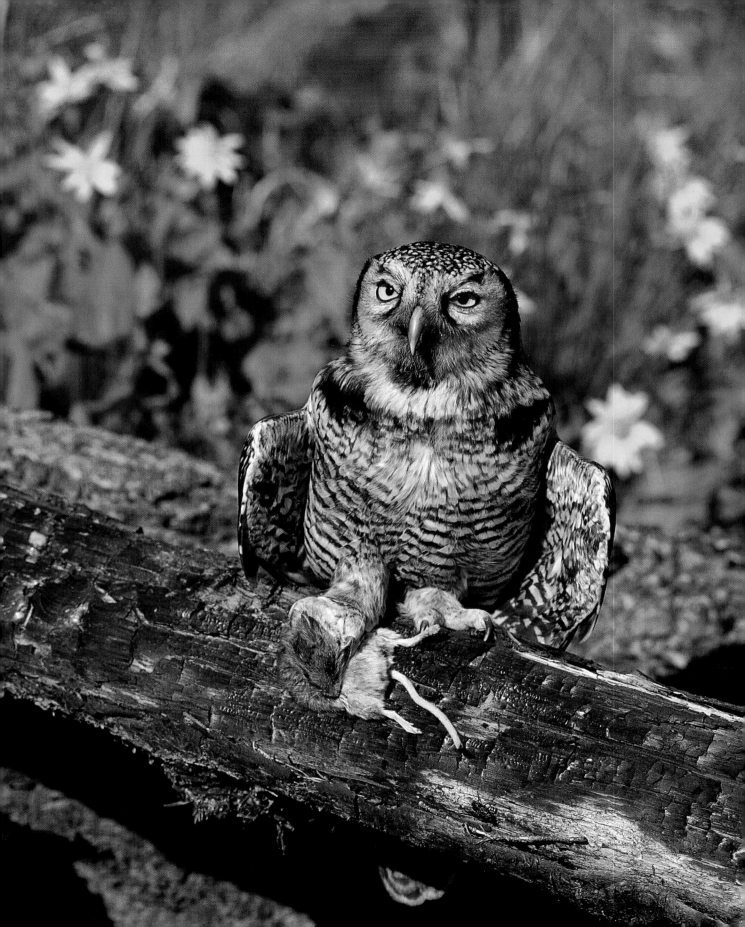

THE NORTHERN HAWK-OWL

*S*urnia ulula is approximately 18 inches (45 centimeters) long with plumage that is predominantly chocolate brown, decorated by white bars on the undersides. The face has white "eyebrows" and semicircles of white around the eyes, the irises of which are lemon yellow; the beak is also yellow, but of a softer hue. The feet are light brown and the claws are black. Like all owls, the northern hawk-owl hunts at night, but living as it does in the far north and under the aegis of the "midnight sun," it hunts regularly in daylight. Of course, during the long nights of its northern range, especially in the extremes of the Northwest Territories, the Yukon Territory, and north-central Alaska in the west and in Labrador in the east, it has no option but to hunt in darkness during the long nights of winter. Nevertheless, the hawk-owl is in no way incapacitated by the rigors of its northern range. To the contrary, this bird is as much at home in the dark as it is under the brilliant sun.

Surnia ulula is native to North America and especially to Eurasia, where it is widely distributed. West to east in the New World, the

Opposite: This northern owl hunts during the day as well as at night.

northern hawk-owl is found to the limit of trees in Alaska, in the Yukon Territory, the District of Mackenzie, southern Keewatin, northern Manitoba, in most of Ontario and Quebec, central Labrador and the Long Range Mountains of northern Newfoundland, thence to northwest British Columbia and south in the Rocky Mountains, then eastward through Alberta, Saskatchewan, Nova Scotia and New Brunswick.

Hawk-owls spend considerable time perched on dead branches of trees, their long tails either drooping down, or held upright. In such perches, the owls often utter their territorial calls, which consist of prolonged series of whistles. The calls have sometime been referred to as repeated *ululas*, a term from the Latin which means "wolf howl," and which I find odd in relation to the bird's prolonged whistle!

This owl also utters calls similar to those of hawks, a series of repeated *kee kee kees*. Another typical call is uttered by the male intent on attracting a female, or during courting, and has been referred to as a long bubbling, or trilled whistle. It may go on for between ten and fifteen seconds and is uttered during display flights.

Repeated, long-lasting shriek calls are uttered by both birds when alarmed, or when seeking to intimidate, as is often the case when humans are in the vicinity, to which I can testify.

The hawk-owl's breeding habitat varies from relatively open country—but where suitable nesting trees are available—to coniferous forests or, and probably more preferably, mixed coniferous–deciduous forests.

Outside of the breeding season hawk-owls are likely to be found in a variety of open locations, such as in the area of farmlands along which trees are found, and they may even forage further south, in prairie regions, where cottonwood trees offer a variety of perches.

Hawk-owls feed on voles, shrews, mice, lemmings, ground squirrels, weasels, snowshoe hares, birds such as ptarmigans, ruffed

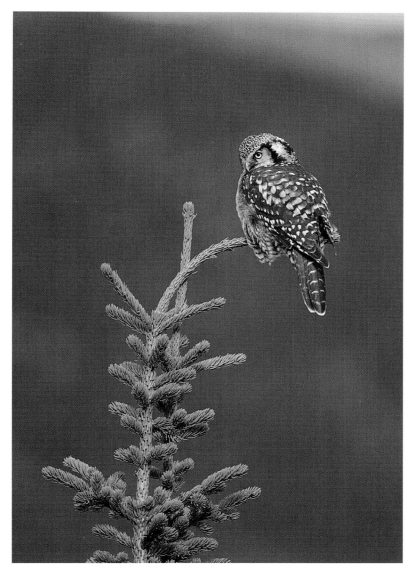

Perched on a treetop, the northern hawk-owl resembles a broad-winged hawk. Its swift, low flight is also hawk-like.

grouse and sharp-tailed grouse, and, in fact, on any mammal or bird that can be subdued.

Breeding season occurs in April to early May, depending on climatic conditions and range. The nest is an unlined hollow in a natural tree cavity, the enlarged nesting hole of a flicker or pileated woodpecker, or the abandoned nest of a crow or raven. Height from the ground may vary from about 6.5 feet (2 meters) to as high as 52 feet (12 meters).

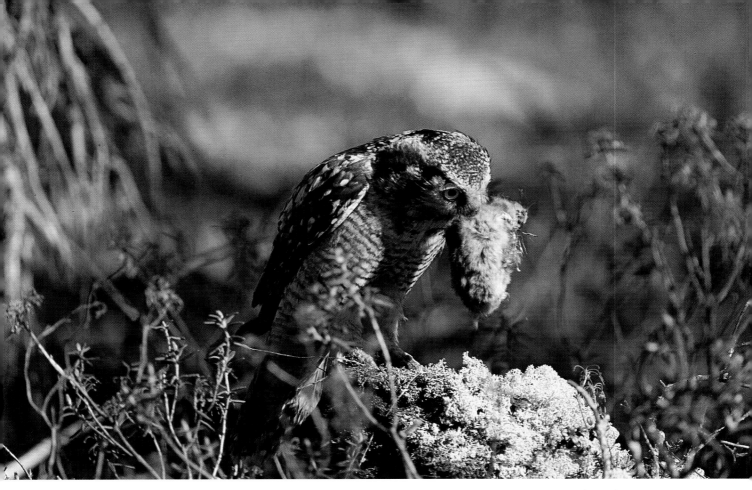

A hawk-owl with its prey.

Clutch sizes vary from three to as many as ten eggs, and incubation is done by the female alone, starting with the first egg. The young emerge between twenty-five and thirty days. They are helpless and downy at first. The down is white with a yellowish to buff tone. The male is said to take turns incubating, but spends most of his energy feeding the female, the fledglings and himself.

It is reported that young hawk-owls gain weight at an enormous rate. Each chick intakes as much as 0.3 ounces (8 or 9 grams) a day and is fed by the male at a rate that is at least three or four times more often than other owls. No doubt this is because the parent bird is able to hunt day and night, especially so in latitudes where the days are long and where, therefore, prey animals are easy to find and active for a longer time than similar species farther south.

Young hawk-owls fledge when they are between twenty-four and thirty-three days old. They are exceptionally active and tend to leave

the nest when they are about three weeks old, at which time they perch on nearby branches and are fed there by both parents. Later, when two months old and able to fly relatively well, they remain in the vicinity of the nesting tree. It is noted that young hawk-owls are not fully independent until they are about three months old.

MEASUREMENTS

	Female	Male
Wing:	9.6 in / 240 mm	10.0 in / 250 mm
Tail:	7.2 in / 180 mm	7.6 in / 189 mm
Length:	16.5 in / 42 cm	15.7 in / 40 cm
Weight:	13.4 oz / 381 g	11.5 oz / 327 g

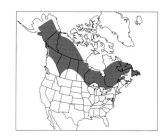

Eggs

Description:	1.6 x 1.3 in / 40 x 32 mm. White, smooth, glossy; short elliptical to subelliptical.

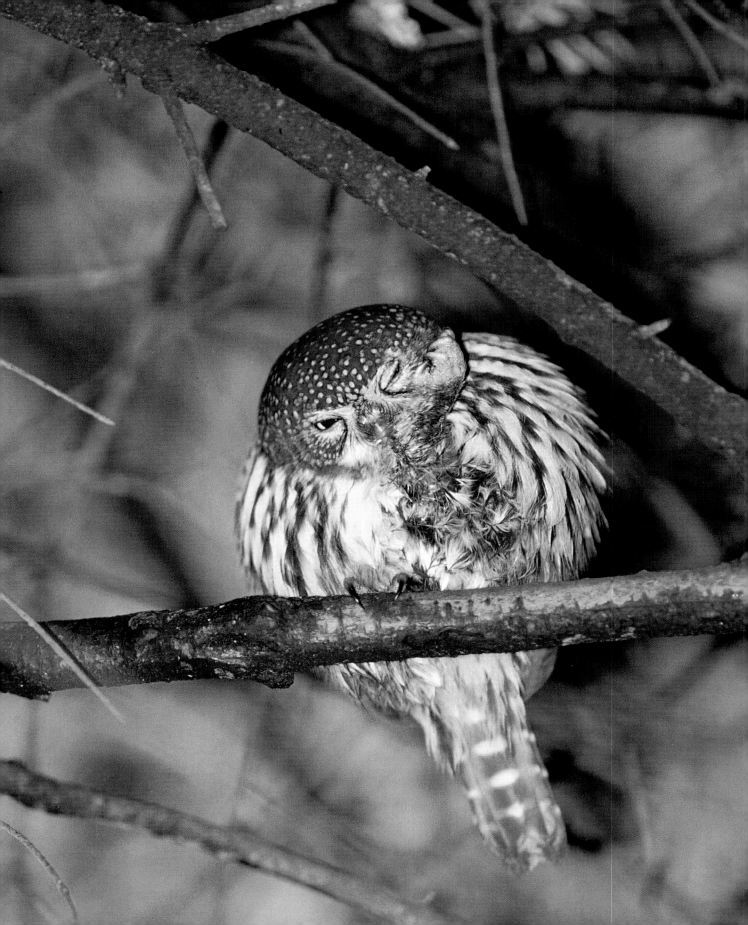

THE PYGMIES AND THE ELFS

T hree species of very small owls live in the Americas and all of them survive not so much because of their size, but because they are aggressive in the matter of food, which they hunt mostly in daytime, or during early morning and late evening. In addition, also due to their size, they often avoid attacks by larger predatory birds because they are difficult to see when sitting absolutely still on a dead branch with their bodies pressed against the trunk of a tree.

The first two birds, the northern pygmy owl (*Glaucidium gnoma*), and the ferruginous pygmy owl (*Glaucidium brasilianum*) each measure 6.5 inches (16.5 centimeters), the size of a downy woodpecker; while the elf owl (*Microthene whitneyi*) measures 6 inches (15.2 centimeters)— the size of a white-breasted nuthatch.

The northern pygmy owl has two color phases: gray and red. In the gray phase, which is the most dominant, the color of the upper parts is gray-brown, the chest and abdomen are white streaked by gray bars and the head is "peppered" by light dots.

Opposite: As this photograph suggests, the northern pygmy owl is an aggressive hunter, sometimes attacking birds larger than itself.

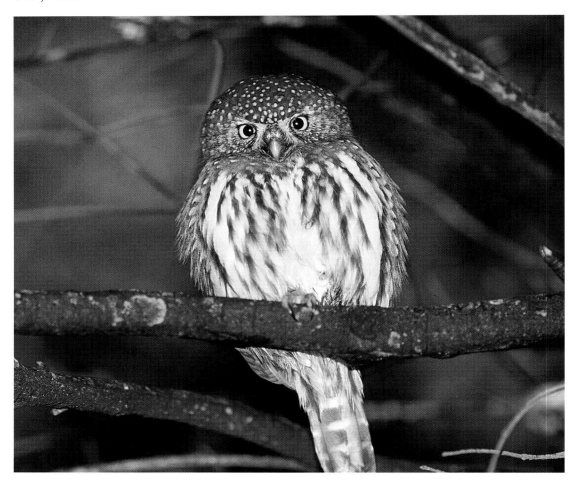

To locate a northern pygmy owl, birders often listen for the scolding calls of songbirds. This owl is frequently mobbed by groups of songbirds.

The beak, eyes and feet (in both phases) are yellow. Both phases also have black bars on the nape of the neck, one on each side, that look somewhat like elongated, upward slanting eyes. Although the colors and the size of *Glaucidium gnoma* are as described for North America, it should be noted that most of the information currently available for this species comes from its related counterparts in Eurasia (*Glaucidium passerina*).

Glaucidium gnoma has a distinctive series of single notes that are uttered in pairs, or in threes and fours. They appear to be part of a repertoire of high-pitched "too" notes, which the bird utters hurriedly and on even pitch. These calls begin rapidly, almost connected to each other: *too-too-too-too-too-too*; then they become spaced: *toot, toot,*

toot, toot. The owl may also simply call once, pause, then call again, after which it may return to its rapid tooting calls.

The food of the northern pygmy owl is varied and includes a long list of mammals and birds, insects, snakes and amphibians, although on the whole these owls seem to prefer mice, large insects and lizards, which they capture by lying in wait. When prey appears on the ground or in the air, the owl launches itself suddenly from an elevated perch and glides down silently behind the prey, which it grasps with its quite large, very sharp claws, and quickly kills by biting the neck; then it flies up to its perch with the prize.

Glaucidium gnoma hunts mostly in daytime or in the early morning and late evening, such activity probably depending on the amount of food it has earlier eaten or accumulated, and whether or not an owl is hunting for itself or for its mate and nestlings. But studies of its counterpart (*Glaucidium passerina*) in Germany, Austria and Finland, indicate that the birds hunt more actively during sunrise and sunset, although a certain amount of hunting continues during periods of the day, especially at midday during the height of the breeding season, at which time some night hunting also occurs.

Outside of the breeding season, northern pygmy owls tend to be rather solitary, likely because they are regularly preyed upon by larger owls and hawks. Because of this, the little owls conceal themselves when not hunting, sitting upright against a tree trunk with their heads turned toward the area of danger, their small ears raised and their eyes either closed or slitted.

Glaucidium gnoma is resident from central British Columbia (possibly also breeding in southeastern Alaska), in southwestern Alberta and western Montana; then south, mostly in mountain regions, to southern California, central Mexico and Guatemala, then extending eastward to central Colorado, central New Mexico, extreme western Texas and southern Baja California.

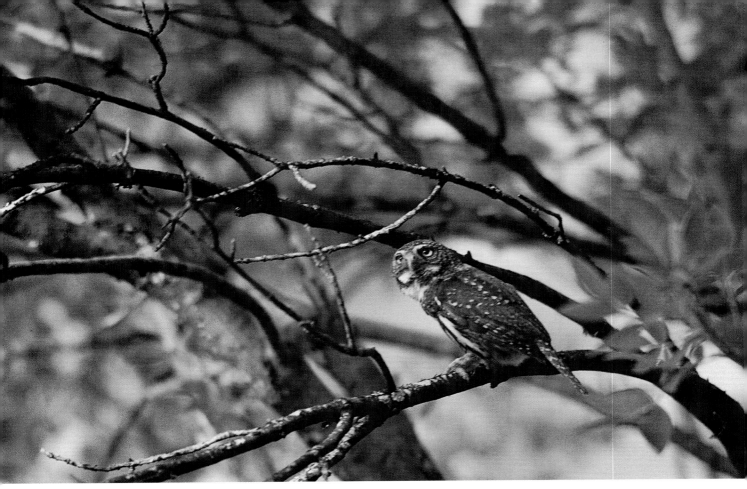

The northern pygmy owl lives in coniferous and mixed woodland.

Six subspecies are recognized: *G.g. swarthi*: Vancouver Island; *G.g. grinelli*: coastal British Columbia; *G.g. californicum*: Northern Interior, British Columbia, and then east to Colorado and northern Coahuila; *G.g. gnoma*: southern Arizona south to Guerrero and Chiapas; *G.g cobanense*: Cuba and the highlands of Guatemala; and *G.g. hoskinsii*: Baja California in the Cape District.

The ferruginous pygmy owl is not found in Canada. It ranges from south-central Arizona, Sonora, Chihuahua, Nuevo León and southern Texas, thence through Mexico to southern South America at least as far south as Argentina and may reach Tierra del Fuego. There is a montane form, *Glaucidium nanum*, which is found from Costa Rica to Bolivia and is included in the species by some ornithologists.

This owl is gray-brown with a rufus tail. The sexes look alike. Like its relative, the northern pygmy owl, it is most often active in

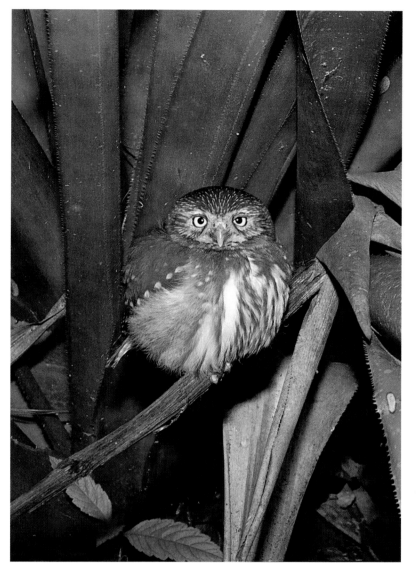

The ferruginous pygmy owl is a southern owl that prefers to live on its own outside the breeding season. This one was photographed in Belize.

daylight and flies with fast wing-beats, usually close to the ground, where it preys on small lizards and ground-feeding birds. Vocalization is said to be a distinctive whistling, or popping call, but its repertoire is not well understood, although it is believed that one call, used by the male to attract a female, is usually uttered at first light and consists of a long, rapidly uttered series of whistled notes.

When not courting and later feeding the female and young, *Glaucidium brasilianum*, somewhat like the other pygmy owls, is antiso-

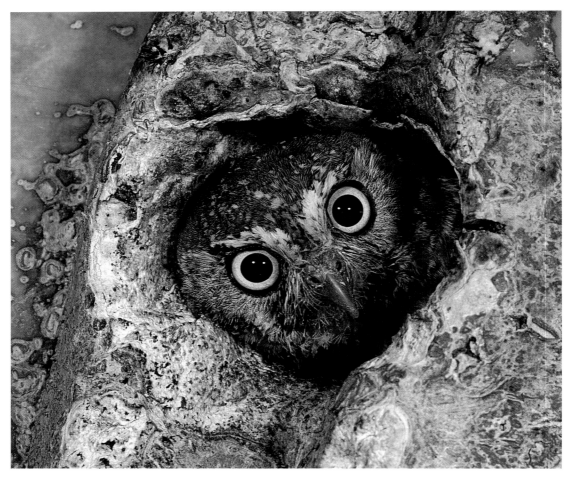

The elf owl nests and roosts in holes in trees, saguaro cacti, and utility poles.

cial, living alone, or, at most, in the company of another owl. It is believed that outside of the breeding season these owls are evidently always ready to drive away others of their own kind, even their own offspring, as well as the female with which they have mated.

The food of this aggressive little predator consists of almost anything that it believes it can subdue. Although its main prey species are small, such as mice and voles, crickets, lizards, caterpillars and scorpions, it hunts birds that in some cases are considerably larger than the owl, even attacking young domestic chickens and guans, which are relatively large birds (family *Cracidae*) of Central and South America.

The elf owl is a roundheaded little bird with big eyes and white eye-

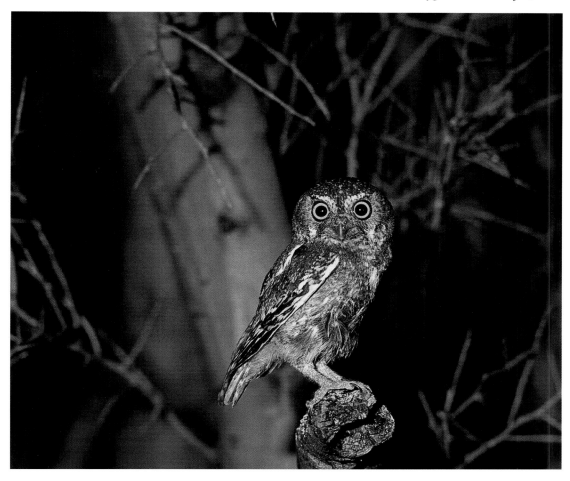

The elf owl, at less than 15 cm in length, is North America's smallest owl.

brows that breeds in southern Nevada, southeastern California, central Arizona, northwestern New Mexico, western Texas, Coahuila, Nuevo León, southern Texas and south to Sonora, Guanajuato, Puebla, Baja California Sur and on Socorro Island.

At 6 inches (15.2 centimeters), this little desert bird earns its living by catching a variety of insects, such as moths, scarab beetles, crickets, grasshoppers, locusts, mantids, spiders and fly larvae. Often, an elf owl will fly off a perch to catch insects with its feet; it also hovers over ground insects until these seek to find escape by flying upward and are then caught, again by the owl's feet.

It has been determined that elf owls have between ten and fourteen calls, including several that are only used by a single sex, such as

one that is used by males seeking to advertise their presence. This call may end after five notes, or as many as fifteen or twenty. It is sometimes repeated for a relatively long time and its purpose is to advertise its territory and to attract a female. Conversely, female owls during the breeding season utter calls that are intended to attract a male and are used before and after the beginning of incubation.

The elf owl and the flammulated owl are the only North American birds that are extremely migratory, undoubtedly because both are highly dependent on insects and must travel south as the colder weather in the north causes their prey to either die off or go into hibernation. Thus, depending on latitude and weather conditions, the elf owl moves south as the climate becomes colder.

Although elf owls do not make a great deal of noise while flying, they are the only owl species that are not completely silent when on the wing, probably because they prey largely on invertebrates, which are not very affected by sound.

Pygmy

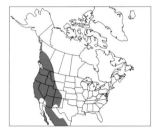

Ferruginous

Elf

MEASUREMENTS

	Female	Male
Pygmy		
Wing:	4.2 in / 106 mm	4.0 in / 101 mm
Weight:	3.0 oz / 86 g	2.8 oz / 78 g
Ferruginous		
Wing:	4.1 in / 102 mm	4.2 in / 104 mm
Weight:	3.0 oz / 84 g	2.7 oz / 76 g
Elf		
Wing:	3.8 in / 94 mm	3.9 in / 98 mm
Weight:	1.6 oz / 44 g	1.3 oz / 37 g

Eggs

Pygmy

Size:	1.2 x 0.1 in / 29 x 24 mm
Description:	White and short, elliptical to short subelliptical; smooth and slightly glossy. Usually 4 to 6. Eggs laid at 3-to-4-day intervals and incubation unlikely to begin until all eggs are laid. Incubation 28 days; the young leave the nest 29 to 32 days later.

Ferruginous

Size:	1.1 x 0.9 in / 28 x 23 mm
Description:	White, short, elliptical and slightly glossy. Usually 2 to 4. Egg intervals and incubation as for pygmy owl.

Elf

Size:	1.1 x 0.9 in / 27 x 23 mm
Description:	White, short, elliptical, smooth and slightly glossy. Usually 3, at times 2 to 5. Incubation starting with first egg: 21 to 24 days. Leave nest between 32 to 35 days.

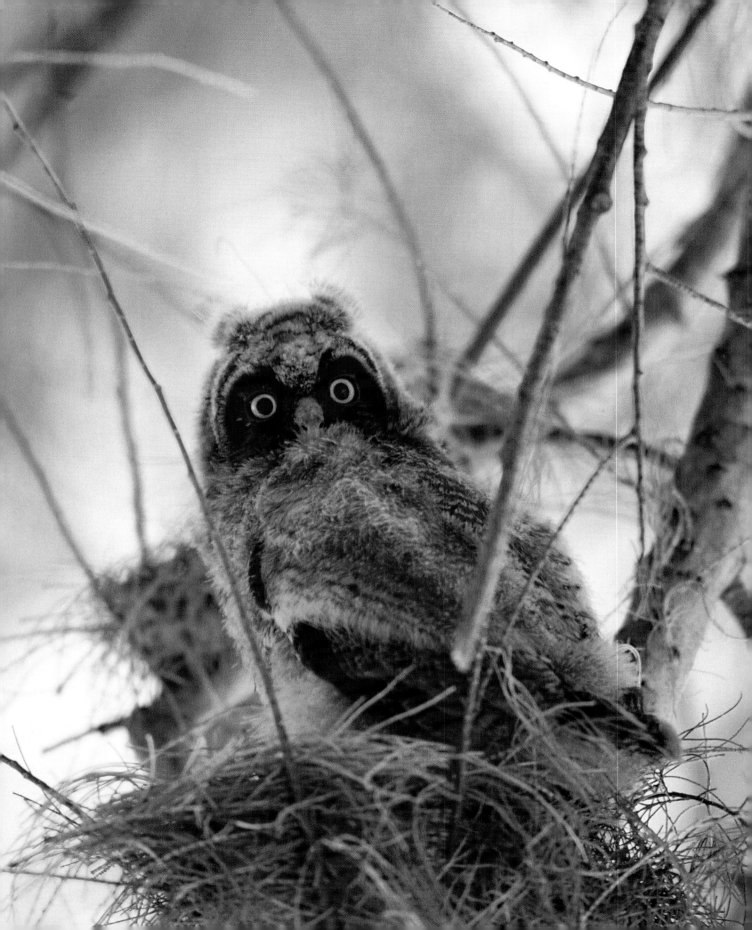

LONG-EARS, SHORT-EARS AND SAW-WHETS

T he long-eared owl (*Asio otus*) breeds in North America from the extreme southeast of the Yukon Territory and the Northwest Territories, east as far as the Notre Dame Mountains in New Brunswick, then due south on the east coast of Canada and the USA as far east as the Appalachian Mountains; next, undulating on the graph, the bird continues westward across the USA to California and is barely found in Mexico but is widely distributed in Eurasia and in North Africa.

During the breeding season, long-eared owls are found in woodlands, the edges of forests and in partly wooded regions where conifers and deciduous trees intermingle, but, at least in Britain, these owls evidently nest within small areas of young planted trees, among scattered trees on moors, in heaths and in locations where mosses predominate. The breeding season is relatively long and in some regions extends from early March to about the end of May.

In Europe, nest site selection varies, but it appears that the abandoned nests of crows and magpies are frequently selected. These owls

Opposite: **A long-eared owlet.**

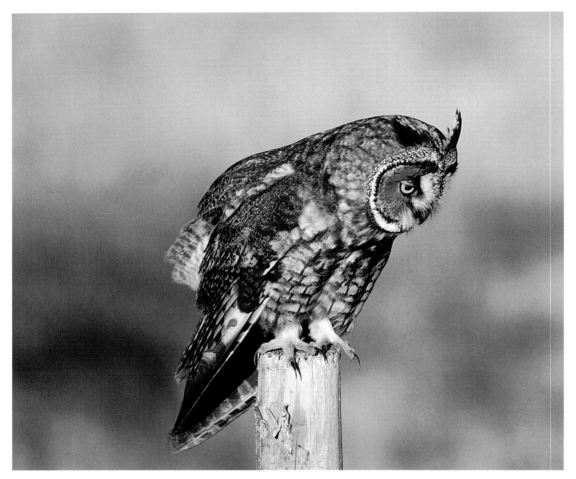

A long-eared owl searches for prey.

also use the abandoned nests of other birds as well as squirrel nests and tree cavities.

Information on nest sites in North America is somewhat sketchy, but it has been found that in Idaho, for instance, most birds use the abandoned nests of crows and ravens which offer heights above ground of between 13 and 17 feet (4 and 5 meters), while in Ontario most nests are in evergreens, such as pines or cedars, which are nearly always alive. Heights in these sites average between 10 and 63 feet (3 and 19 meters).

Long-eared owl females lay their eggs on alternate days so that a clutch of five or six eggs may take eleven or twelve days to be laid. Because incubation begins immediately after the laying of the first

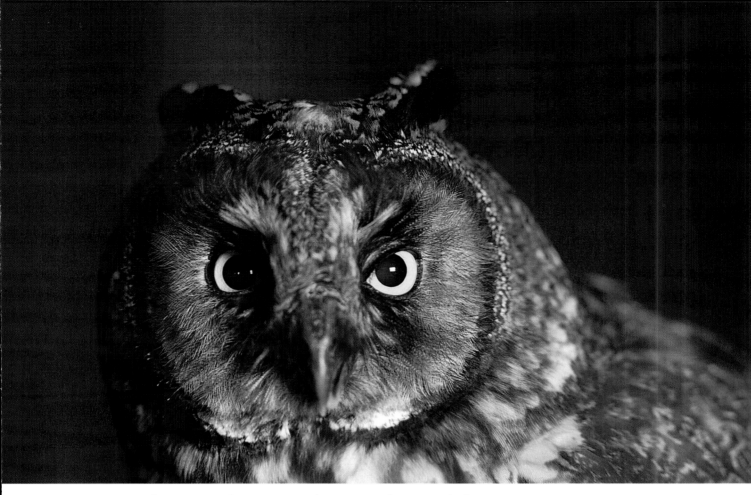

egg, the young are born at intervals, a system that may take between twenty-five and thirty days to complete the hatching.

The long-eared owl is usually silent except in the breeding season when its common call is a long *hoo*.

The chicks emerge blind and dressed in a coat of white down, but five days later they can see, and a week later black feathers start to show around the beak. Somewhat less than a week after that, black feathers cover the entire face like a mask. By the time the owlets are between twenty-five and twenty-seven days old, they leave the nest and start to crawl over the branches of their birth tree, despite the fact that fledging is not complete until they are between thirty and forty days old, when their feathers have become well developed. At about two months of age, the owlets start to become independent of their parents.

Considerable information is available on the food consumed by the European long-eared owl and, according to S. Cramp in the *Handbook of the Birds of Europe, the Middle East and North Africa*, samples

from central Europe established that voles were the major prey and accounted for about two-thirds of about 120 species. This information coincides with two studies done in North America, which demonstrated that voles were also the most common prey of the long-eared owls in two sampled areas, although samples taken from five other regions established that mice were the most common prey in those North American studies. Nevertheless, up to some forty-four species of mammals, some as large as snowshoe hares, have to date been reported as prey in North America, and at least twenty-two species of mammals have likewise been reported from Europe.

Long-eared owls hunt by flying over open country at heights of between 16 and 20 inches (40 and 50 centimeters). Quartering over an area, an owl captures the prey by stalling suddenly and dropping on the quarry with talons spread, pinning the prey to the ground and immediately thereafter biting its neck, killing it almost instantly.

During the breeding season, the nest is selected by the female almost as soon as she has been attracted to the male and to his territory. While she is inspecting and perhaps tidying the nest, the male spends his time hunting for himself and for his mate.

Apart from this owl's long ears, which are unmistakable, the most striking aspect of the bird's color is the face, which is surrounded by a frosty white line from "chin" to the top of the head. Inside this line, on either side of the beak, there are cinnamon-brown, hornlike semicircles, while on either side of the black beak there are white streaks that give the impression of a frosted mustache. On either side of the yellow eyes, "eyebrows" form a V shape, between which the tone is buff but peppered by light brown dots. The feet are yellow, the claws black and the rest of the body is covered by brown and light tan feathers that are decorated by whitish patterns. Seeing a long-eared owl close up, one is inevitably reminded of the color, the face and the ears of the great horned owl, although the "ears" of the latter are somewhat short and wider than those of *Asio otus*.

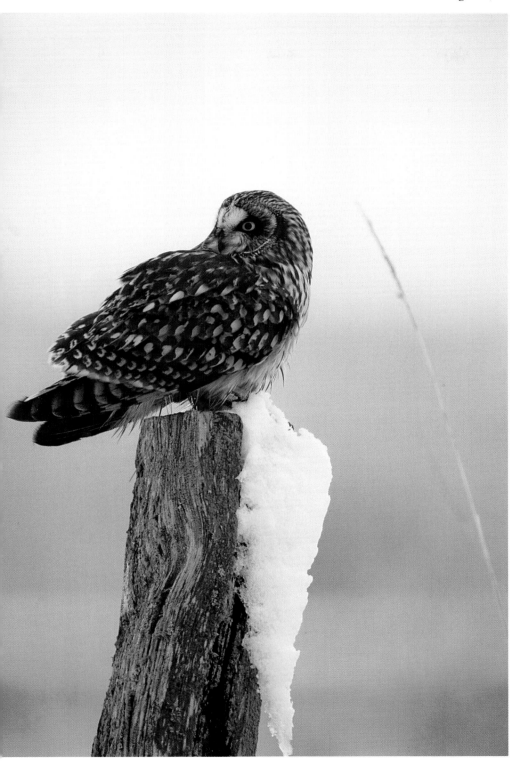

Short-eared owls are open
country birds, inhabiting
meadows, marshes, bogs and
tundra. They sometimes watch
for prey from fence posts and
other elevations.

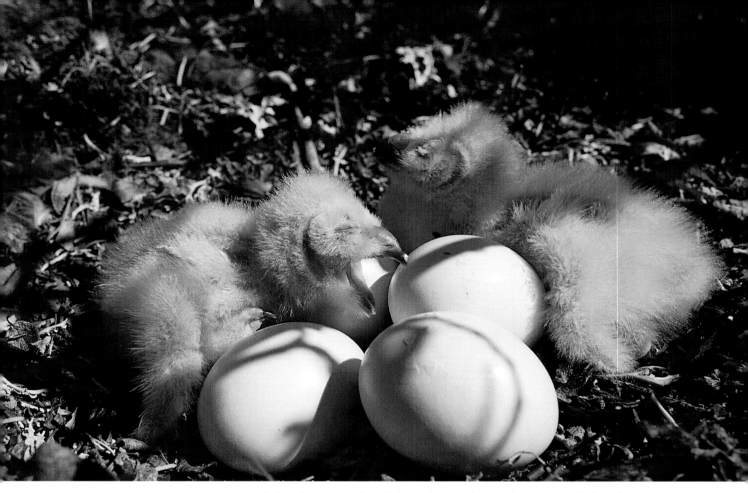

Short-eared owls make rudimentary nests on the ground.

The short-eared owl (*Asio flammeus*) is at home in Alaska, the Yukon Territory, the Northwest Territories and right across Canada. Then it crosses the United States from east to west (or vice versa), starting in California and continuing eastward as far as New Jersey. If that were not enough territory for the species, *Asio flammeus* flits across the Bering Sea and is found on the British Isles and right across Eurasia, especially into Norway, Sweden, Finland, Germany and southern Europe. It also lives in South America, all the way down to Tierra del Fuego.

Geographically, population numbers vary considerably and in accordance with the densities of prey populations, but it is known from U. N. von Blotzheim Glutz and K. M. Bauer's 1980 European study that the breeding densities range from one to about six pairs per square kilometer (0.4 square mile). As a comparison, some years ago in Manitoba, an area of approximately 15 square kilometers (6 square

miles) offered about eight territories that were suitable for breeding and provided sufficient space and prey species for one pair per square kilometer, a density much lower than that found in the European study which, of course, hinged upon the availability of food.

When breeding, these owls appear to have rather small territories and home ranges, a fact noted during four European studies. The ranges were found to vary from 34.5 acres (14 hectares) in Germany to 494 acres (200 hectares) in Finland.

Short-eared owls are relatively migratory, but the exact numbers that migrate in North America are uncertain, especially compared to banding data from Europe. In Finland, for example, in addition to distinct, north-to-south migration routes, there is evidence to suggest at least that these owls are also nomadic. In fact, banded birds from Finland have been found in Scotland, and some Dutch and German short-ears that were banded as juveniles were in time recovered as far north as northern Scandinavia and as far east as Sverdlovsk, Russia.

The year-round prey of short-eared owls in North America consists of mammals, of which the majority are voles; in addition, the owls hunt mice, shrews, insects and birds, such as meadowlarks, killdeers, horned larks and red-winged blackbirds.

Short-eared owls hunt most often by engaging in prolonged coursing flights, when they are somewhat less than 6.5 feet (2 meters) above the vegetation and, like other owls, flying into the wind to prevent the prey from scenting the hunter while the hunter can see and scent the prey. Occasionally, they may watch from fence posts or other elevations while, with bodies still, they watch for prey, their heads swiveling slowly, ears concealed, and alert for even the slightest sound or movement. In Europe, short-eared owls are reported to hunt at all times of the day as well as during the night, information that suggests that these owls may be more diurnal than other European owls. However, they are said to prefer to hunt during late afternoon and late evening.

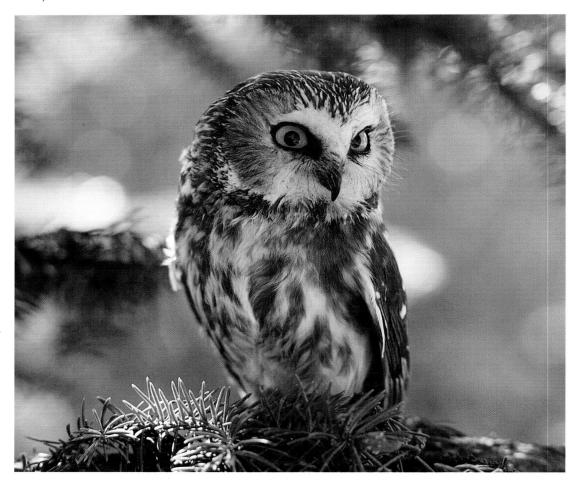

The northern saw-whet owl hunts at night and roosts during the day in the coniferous forests, mixed forests and tamarack bogs of its range.

Short-eared owls have a most expressive face. At one moment they erect their ears, probably because they have heard or seen something of interest, but at the next the ears are hidden, the head again rounded. In fact, seeing them in the different postures, casual observers might think that they have seen two different kinds of owls, for when the ears are hidden, the bird's eyes are enhanced by a surrounding of relatively large black patches and by white half-moons, one on each side of the beak. The face then presents a rounded, calm appearance. When the ears are raised, however, and the feathers between and above the eyes are smoothed back, the eyes glare and the face becomes almost catlike, or angry.

The breeding season of short-eared owls varies according to loca-

tion, that of birds in Alaska or Arctic Canada not beginning until early June, in Manitoba in May and in Minnesota in March.

The saw-whet owl (*Aegolius acadicus*) is perhaps one of my favorite birds, not simply because a female of the species "adopted" me two years ago and hitched rides on my shoulder, but also because the male's repetitive song reminds me of the days when, as a tenderfoot logger in Northern Ontario, I often had to sharpen my one-man crosscut saw, filing the teeth on both sides and creating the kind of strident, yet tuneful sound that is very similar to the call of *Aegolius*. Indeed, the first time I heard the little owl's call was during an almost pitch black night, when I had opened the door of my home preparatory to go outside to my well to draw a bucket of water. But I stopped just outside the door when I heard the sounds and I immediately became convinced that someone was playing a trick on me, despite the fact that my nearest neighbor was more than a mile away and that no vehicle had stopped nearby. Yet I was convinced that someone was sharpening my saw, which I had filed that afternoon, and I became annoyed. Some fool of a prankster, I thought, had sneaked into my property and was filing the teeth of a crosscut, perhaps my own, so I reentered the house, picked up a powerful flashlight and went out to investigate.

Minutes later I was satisfied that there was no one in my shed, nor in the near vicinity of my home, yet the saw sharpening sound continued. And it was near!

I set out to search the surrounding forest, which was not far, inasmuch as I had as yet only cleared a relatively small area immediately around the house. Walking slowly and stopping often, guided by the source of the sounds while aiming the flashlight beam at about shoulder height at first, I was lured to a place twenty or thirty feet from my building. I then realized that the calls came from above the ground. Lifting the beam, it took only a moment or two to locate the source of the calls.

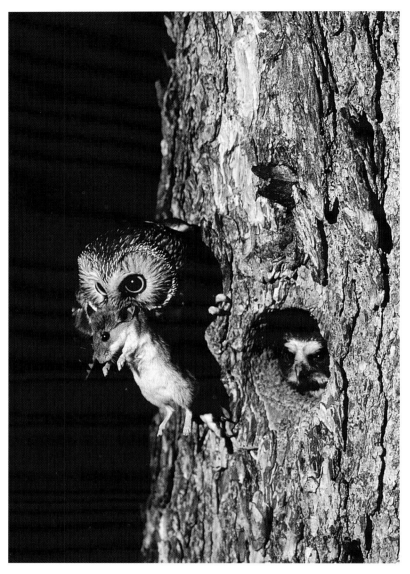

Rodents form a major part of the saw-whet's diet.

As it happened, some time earlier I had bought a bird book, so when I saw the owl, I knew that it was a saw-whet and I knew also that it had been named for its unusual call.

The little owl was sitting on a dead branch of a tamarack about eight or ten feet from the ground and despite the fact that it was illuminated by the beam of my light, it continued calling at intervals.

That was my first experience with saw-whet owls. Since that time I have seen nineteen at different times, on different perches, or at the

nest, the last one to date being the female that rode on my shoulder. In due course, her mate led me to her nest during his frequent feeding trips. She remained on her nest after I set a ladder against the tree and climbed up to the level of her home—nine feet from the ground. That bird actually allowed me to count her eggs while she remained sitting on them inside the cavity that had probably been excavated by a pileated woodpecker. By feel, I counted five eggs.

Later, after the chicks had emerged but were still in the female's care, I visited the tree a few times, heard the young peeping and watched the male as he diligently fed his mate, who in turn, of course, fed the young, but I did not intrude further. When the family had left the nest, however, I climbed up to look inside. One egg had not hatched and had been pushed to the far end of the unlined nest. Since it was not cracked, I took it home, where it spent some time on my filing cabinet—until a young cat knocked it down!

Saw-whet owls breed from southern Alaska, southern Yukon Territory, central British Columbia, the Queen Charlotte Islands, Vancouver Island, central Alberta, central Saskatchewan, central Manitoba, central Ontario, southern Quebec, northern New Brunswick, Prince Edward Island and Nova Scotia and then southward to California, the Mexican highlands to Oaxaca and southern New Mexico, western South Dakota, central Minnesota, northern Illinois, southern Michigan, central Ohio, West Virginia, western Maryland and New York. They usually winter in their breeding range, but part of the population, said to be mostly immature birds, migrate south regularly.

Saw-whet owls prey heavily on rodents such as deer mice and white-footed mice, but they also prey on voles, shrews, bog lemmings, flying squirrels and some birds.

MEASUREMENTS

	Female	Male
Long-eared		
Wing:	11.7 in / 292 mm	11.6 in / 290 mm
Tail:	6.0 in / 150 mm	5.8 in / 145 mm
Weight:	12.0 oz / 340 g	11.1 oz / 316 g
Short-eared		
Wing:	12.4 in / 310 mm	12.5 in / 312 mm
Tail:	6.0 in / 150 mm	5.9 in / 149 mm
Weight:	16.5 oz / 469 g	12.7 oz / 360 g
Saw-whet		
Wing:	5.7 in / 142 mm	5.5 in / 137 mm
Tail:	2.9 in / 72 mm	2.7 in / 68 mm
Weight:	4.3 oz / 122 g	3.5 oz / 98 g

Eggs

Long-eared	
Size:	1.6 x 1.3 in / 41 x 33 mm
Description:	White, short elliptical. Smooth, moderately glossy and finely pitted. Usually 4 to 5 (rarely 3 to 8). Eggs laid on alternate days, incubation complete 25 to 30 days.

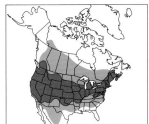

Long-eared

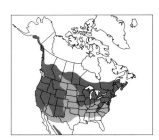

Short-eared

Saw-whet

Short-eared

Size:	1.6 x 1.2 in / 40 x 31 mm
Description:	White, short elliptical. Nonglossy, smooth. Usually 4 to 8, rarely 3, but up to 14 if food is plentiful. Eggs laid at 2-day intervals. Incubation complete 24 to 28 days.

Saw-whet

Size:	1.2 x 1.0 in / 30 x 25 mm
Description:	Elliptical to short-elliptical. White, smooth, non-glossy or slightly glossy. Usually 5 to 6, at times 4 to 7. Eggs laid at 2-day intervals. Incubation complete between 26 and 28 days.

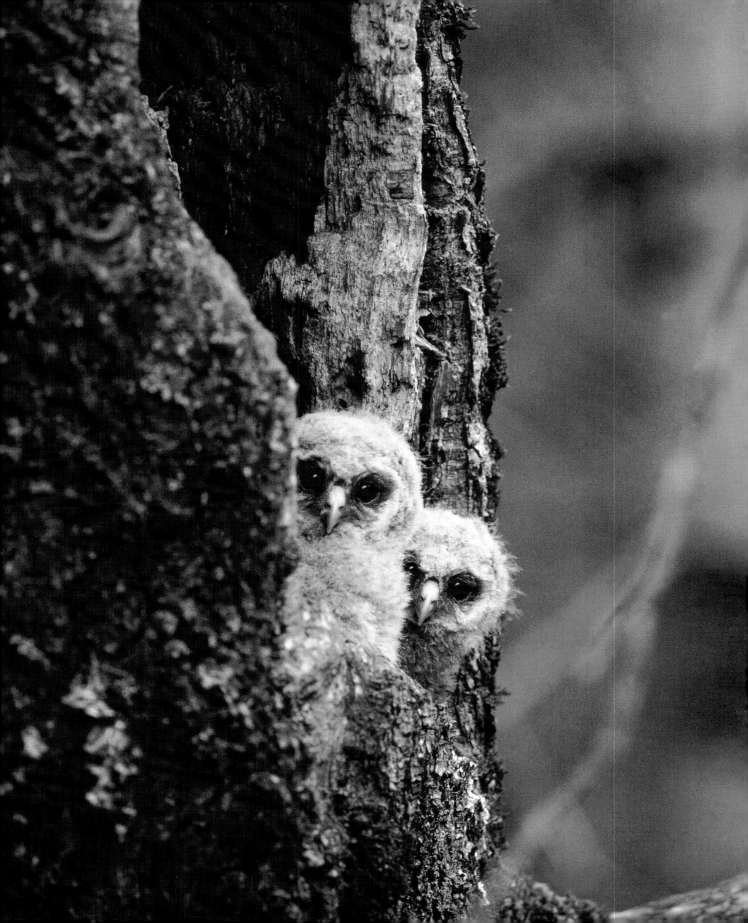

AFTERWORD

A fter a great many years of seeking and counting, ornithologists past and present have concluded that there are *at least* 8600 species of birds inhabiting our planet. Such numbers are mind-boggling, especially when one realizes that birds as a group today are the most remarkably successful organisms ever known since the demise of the dinosaurs. What is more, birds continue to breed of their own kind to the extent that some ornithologists have come to believe that periodic changes in individual species have probably given rise to still more bird subspecies, which, in their turn, will become actual species.

Birds, because they have been—and continue to be—very capable of adapting to change, have also been able to colonize all those regions of the world that can even marginally sustain their needs, so that with the exception of the deep oceans, the barren deserts and the uppermost, ice-covered mountain peaks, birds, including owls, can be said to feel at home virtually anywhere in the world. In fact, according to some authorities, there are about 140 species of owls

Opposite: Spotted owl chicks look out from their nest in a black oak located in Yosemite National Park, California.

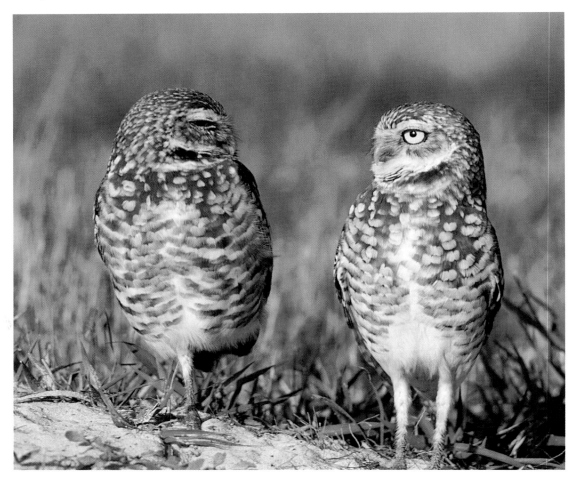

A pair of burrowing owls.

that colonize practically every land mass worldwide, with the exception of some barren oceanic islands and in Antarctica.

Birds, like mammals, have personality as well as individuality, which is to say that a bird has a mind of its own as well as "personal" physical structures, vocalizations and differences that set it aside from all other birds of the same species, including the size and the color and the tones of its feathers. In fact, no matter of what species, whether it is a great horned owl or a hummingbird, every bird differs from its neighbor in looks and in personality. And let there be no mistake: birds have individual personalities.

The various owls that I have rescued were all individualists. Not only did the call of each bird differ from any of the others that I

cared for, but each of them treated *me* differently. One of my great horned owl friends, for instance, always landed on my left shoulder and nibbled on my ear. Another, a female, would only perch on my left wrist, close to my hand. In both cases their behavior did not change.

I became aware of the individuality of birds twenty years ago, and I wondered why it had taken me so long to make the discovery inasmuch as I had learned at an early age that all mammals are as individualistic as humans, that each, although belonging to a particular species, looked different from its companions and quite clearly behaved differently.

Over the years I have met many people who believe that birds are simple creatures that function automatically, that they merely responded to a limited number of behavioral, inbred characteristics. Most of those people I have been able to convince (by actual demonstration) that birds are intelligent and not automatons born with rigid routines. Nevertheless, a small number of individuals have persisted in the belief that birds, and, indeed, all other animals, are born with the same blueprints.

A bird's ability to fly, which to an observer appears simple, is, in fact, particularly complex, so much so that some aspects of flight are still not fully understood. When a bird is gliding with outstretched wings its behavior is similar to that of an aircraft's wings, lift being generated by the forward movement through the air. On the other hand, when a bird flaps its wings, it goes one better than a fixed-wing aircraft, for its wings are then able to achieve immediate lift-off, like a helicopter, or, conversely, immediate descent, in essence behaving as propellers by pushing the body up and forward, or down and forward, depending on their angle. Then, too, when a bird is flying fast, the wings, as everybody knows, perform an up-and-down motion. This is achieved because the motion is derived when the outer edges of the wings beat up and down. So, while an aircraft's propeller rotates rapidly while the machine moves forward on the ground in

order to in due course achieve lift-off thrust, a bird's wings, acting somewhat like a propeller, almost immediately drag its body forward and upward. In fact, seen in section, a bird's wings are quite similar to the wings of an aircraft, being convex above, concave below and with their leading edges rounded and their trailing edges thin.

The secret of bird flight is the ability of the feathers to automatically change their shapes while the wings are beating, for the rear edges of the primaries are broader and have more flexibility than the leading edges. However, when taking off, or when hovering, a bird must beat its wings rapidly in order to gain height or to remain in one place. Taking off, incidentally, requires the expenditure of considerable energy if a bird is to rise quickly, which is why when on the ground most birds use their legs to spring upward so as to get a head start and to allow their wings to beat effectively without hitting the solid surface and perhaps soiling their wings.

Nevertheless, every time that a bird rises from the ground, or from a rock, or a tree limb, some grime is picked up by the rapidly flapping wings. Much of the accumulation is jettisoned by air thrust, but residual dirt can, and does, remain. For at least that reason, owls, like most other nonaquatic birds, take a shower now and then, standing in shallow water at the edge of a stream or lake, while flapping their wings rapidly in order to splash water over themselves. On occasion, however, an owl will deliberately immerse its entire body into fairly deep water, an event that I observed some years ago when during a night of full moon I saw a barred owl glide down and almost totally immerse itself in lake water, momentarily causing me to believe that the bird was going to drown. But as I prepared to move forward to rescue it, the bird began to splash, flinging water over itself and causing a fine misty aura to fly over its immediate surroundings.

Then, too, some birds, including owls, resort to what has been termed the "plunge bath," although the action is more like a dip bath, for owls—as well as swallows, nightjars, swifts, kingfishers and hum-

mingbirds—fly at a low angle and splash briefly in the water, immediately thereafter flapping upward to fly to a perch, there to begin to use their beaks to spread oil over their feathers, supplies of which are derived from their preen glands, located at the base of the tail. The function of the oil, it is believed, tends to increase the surface tension of the feathers and it is likely that the oil prevents the feathers from becoming brittle. It may also be that the oil has fungicidal and antibacterial properties.

Owls and other birds, of course, spend a considerable time preening, behavior that involves a number of gentle, sensitive movements of the beak, the most thorough of which consist of the gentle nibbling of each feather, starting at the base and finishing at the tip. Such action, aided by the oil, cleans and rearranges barbs and barbules.

All those owls that I have closely observed preened at regular intervals, whether they did so after taking a bath, or when they were sitting on a perch. At such times, I noticed that they would pause momentarily to pick up a louse, crunch it and swallow it, then, beginning at the base of a shaft, they would draw a feather rapidly through their beak, a movement that invariably smoothed the feather and which was repeated on feather after feather. When all were done, an owl would shuffle all its feathers quite vigorously before fluffing them out and allowing each feather to return to its proper place. But the preening did not end until the owl beat its wings for some moments, after which it would again rearrange its feathers.

Apart from the fact that owls quite evidently enjoy a dip or two now and then, it may well be that the main reason for bathing has to do with the removal of at least some external parasites, of which the Mallophaga are probably the most common on owls, other birds and mammals, although the minute pests, which belong to a large order of wingless insects, do not prey on humans. They do, however, crawl on a person's hands after a bird has been examined.

Some species of Mallophaga measure less than 0.04 of an inch

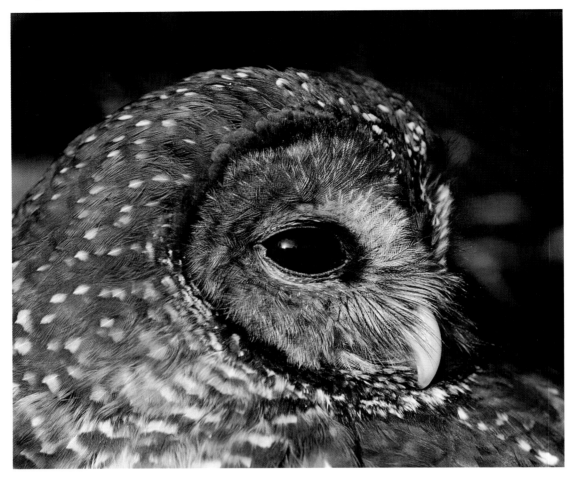

The endangered spotted owl.

(I millimeter), and the largest of the species, which are found on some hawks, are giants that attain 0.4 of an inch (10 millimeters) in length and have also been found on great horned owls.

Mallophaga are photonegative: they avoid light and for that reason they spend their entire lives on their hosts. Thus, when a bird dies, if the parasites are unable to find a new host quickly, which rarely occurs, the lice die also.

Disease and parasite infection are rarely absent from owls, other birds and mammals and it says much for the constitution of the hosts, especially of owls, that diseases and parasites are rarely, if ever, absent from them.

Disease is usually caused by internal parasites, viruses, bacteria

and fungi, of which bloodsucking parasites are a particular problem as carriers of illness. Some kinds of mosquitos, for example, which feed on the blood of birds, transmit encephalitis from one host to another. Other kinds of mosquitos, such as the *Anopheles* species of the genus *Plasmodium*, transmit avian malaria, which is caused by one-celled protozoan organisms that destroy the red blood cells of the bird host. It is known that at least 447 species of birds, including owls, are infected by malarial parasites.

Another serious disease is caused by *Trichomonas gallinae*. This organism, a flagellated protozoan, establishes itself in the throat, liver, lungs and other organs of owls, hawks and a variety of other birds, including domestic chickens.

If the above were not enough, owls and other birds suffer from many other kinds of internal parasites, including roundworms, spiny-headed worms, tapeworms and flukes.

Despite being plagued by parasites, however, owls are relatively long-living birds. At least, to my knowledge, one great horned owl survived for fourteen years and two months. This was a captive chick that I rescued in 1955 after an old balsam fir tree that contained the owl nest collapsed during a storm in an area of northwestern Ontario. As it happened, I was cutting firewood when the wind swept over the forest, one of those violent, yet short-lived blows that are common in that region. Being already accustomed to the sudden gales, and therefore aware that the present blast would not last long, I sheltered under a large cedar.

As it happened, the cedar was within a few yards from the downed balsam and, after the blow, I walked over to the tree to see if it was worth cutting it up for my furnace and found that it was very old and quite rotten, and so of no use to me. But, as I was about to leave the area, I heard rustling sounds coming from what had been the upper canopy of the balsam. Investigating, I found an owl's nest that had contained four recently hatched great horned owl chicks.

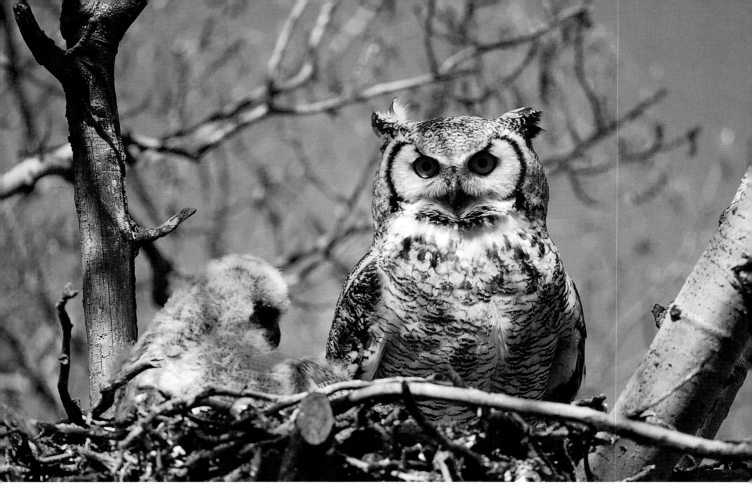

A great horned owl with its young.

Three of the birds were dead, one was alive. This was my first close encounter with great horned owls. At the time, and although I had been given a few, single glimpses of the great shadowy birds as they flew through the forest night while periodically uttering the deep and melancholy calls of their kind, I was not entirely sure of the little one's species. However, I guessed it to be either the offspring of a great horned owl pair or of great gray owls. Moments later, though, as I disentangled the owlet's foot from the rough walls of the nest, I felt sure that it was a relatively newly hatched great horned owl.

The dead chicks had spilled out of the nest and had been crushed and stabbed by branches, but the survivor had managed to hold onto the inside of the nest with one clawed foot. In the event, I picked up owlet and nest and hurried away to examine the chick and, once at home, to discover that its left wing had been broken at a point between what would be a human elbow and the wrist.

Later, after I had covered the bird with two of my wool socks and then placed it, nest and all, in a cardboard box, I left the injured bird at home and returned to the downed balsam to collect the three dead owlets, which I planned to dissect that evening. But as I walked away from the site, the dead owlets in my pocket, I stopped every now and then to listen for owl calls, thinking that perhaps the adults might return. But to no avail. And despite visiting the downed tree on several occasions, I neither saw nor heard the adults, which, if alive, had evidently sought a new nesting tree.

As matters turned out, the owl chick thrived on a diet of finely minced raw chicken and raw beef, egg yolk, finely mashed eggshells for calcium and a variety of other items. Years later I was to learn that some owls have been known to live for seventeen years, and others for up to nineteen years, albeit that such birds were kept in captivity so that whether wild owls will live that long is anybody's guess.

TOPOGRAPHY OF AN OWL

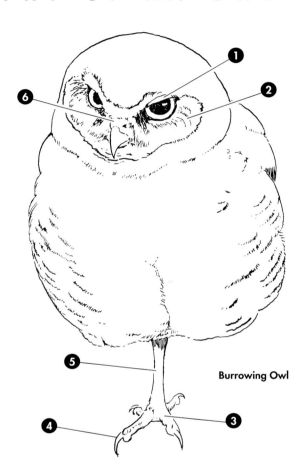

Burrowing Owl

Burrowing Owl

1. Eyelid
2. Ear covert (facial disk)
3. Toes
4. Claw (talon)
5. Tarsus
6. Cere (fleshy area surrounding nostrils)

Great Horned Owl

7. Facial disk
8. Ear-tufts (feathers only; no relation to ear)
9. Nape
10. Ear (hidden behind facial disk)
11. Back
12. Scapulars
13. Lesser wing coverts
14. Middle wing coverts
15. Inner secondaries
16. Lower back (rump)
17. Primaries
18. Retrices (tail feathers)
19. Undertail coverts
20. Outer secondaries
21. Flank
22. Belly
23. Breast
24. Gorget
25. Chin
26. Beak (or bill)
27. Iris (colored part of eye)
28. Pupil (opening in iris)
29. Forehead
30. Crown

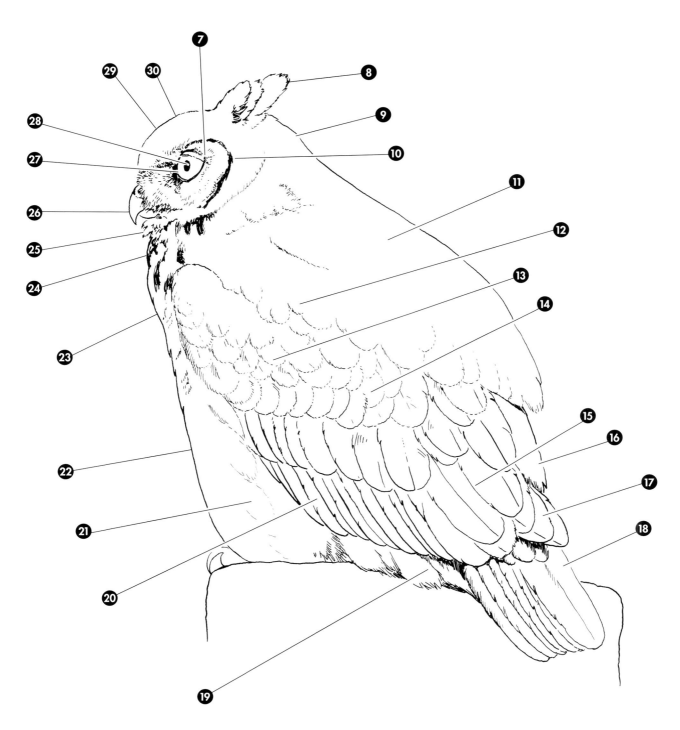

Great Horned Owl

INDEX

PHOTOGRAPHY CREDITS

Page 10: M. S. Quinton/First Light; *13*: © Tom Vezo/The Wildlife Collection; *16*: © Dennis Frieborn/The Wildlife Collection; *22*: © Wayne Lynch; *24*: © Jerry and Barbara Jividen/Images Unique; *29*: © D. Robert Franz; *38*: © Wayne Lynch; *43*: © Robert Lankinen/First Light; *44*: © Wayne Lynch; *45*: © Wayne Lynch; *48*: © Jim Saba/Image Natural; *52*: © D. Robert Franz; *54*: © Wayne Lynch; *56*: © Wayne Lynch; *60*: © Michio Hoshino/First Light; *64*: © Wayne Lynch; *70*: © Wayne Lynch; *72*: © Wayne Lynch; *80*: © Wayne Lynch; *82*: © Wayne Lynch; *84*: © D. Robert Franz; *87*: © Aubrey Lang; *88*: © Robert Lankinen/First Light; *90*: © D. Robert Franz; *92*: © Fredrick Sears; *94*: Thomas Kitchin/First Light; *95*: Thomas Kitchin/First Light; *96*: © Tom and Pat Leeson; *98*: © Wayne Lynch; *103*: © Wayne Lynch; *104*: © D. Robert Franz; *108*: © Tom and Pat Leeson; *110*: © Wayne Lynch; *113*: © John Serrao; *114*: © Tom and Pat Leeson; *116*: © Wayne Lynch; *118*: © John Serrao; *119*: R. A. Behrstock; *120*: © Wayne Lynch; *121*: R. A. Behrstock; *122*: © Phillip Roullard; *123*: © Rick and Nora Bowers/The Wildlife Collection; *124*: R. A. Behrstock; *125*: © Rick and Nora Bowers/The Wildlife Collection; *128*: R. A. Behrstock; *130*: © Rick and Nora Bowers/The Wildlife Collection; *131*: R. A. Behrstock; *132*: Thomas Kitchin/First Light; *135*: © Wayne Lynch; *136*: © Wayne Lynch; *138*: © Fredrick Sears; *140*: © Fredrick Sears; *142*: R. A. Behrstock; *143*: © Rick and Nora Bowers/The Wildlife Collection; *144*: © Rick and Nora Bowers/The Wildlife Collection; *145*: © Rick and Nora Bowers/The Wildlife Collection; *148*: © Phillip Roullard; *150*: © Wayne Lynch; *151*: © Wayne Lynch; *153*: © Fredrick Sears; *154*: © Wayne Lynch; *156*: © Wayne Lynch; *158*: © D. Robert Franz/The Wildlife Collection; *162*: © Michael Frye; *164*: © Wayne Lynch; *168*: © Tom and Pat Leeson; *170*: © Wayne Lynch.